HAUNTED DEADWOOD

HAUNTED DEADWOOD

A TRUE WILD WEST GHOST TOWN

MARK SHADLEY AND JOSH WENNES

Published by Haunted America
A Division of The History Press
Charleston, SC 29403
www.historypress.net

Copyright © 2012 by Mark Shadley and Josh Wennes
All rights reserved

First published 2012

Manufactured in the United States

ISBN 978.1.60949.325.7

Library of Congress CIP data applied for.

Notice: The information in this book is true and complete to the best of our knowledge. It is offered without guarantee on the part of the authors or The History Press. The authors and The History Press disclaim all liability in connection with the use of this book.

All rights reserved. No part of this book may be reproduced or transmitted in any form whatsoever without prior written permission from the publisher except in the case of brief quotations embodied in critical articles and reviews.

For Peggy, the love of my life and my best friend. I love you!
—Mark Shadley

For Amanda, you are my world and I couldn't have done this without you. With love always.
—Josh Wennes

CONTENTS

Acknowledgements	9
Introduction	11
Native American Ghost Stories of the Black Hills	13
Black Hills History	19
The Brothels	35
The "Badlands"	46
The Fairmont Hotel	58
The Bullock Hotel	64
Mount Moriah Cemetery	75
The Adams House	82
The Adams Museum	94
Haunted Deadwood Walking Tour	101
Bibliography	109
About the Authors	111

Acknowledgements

There are so many people behind the scenes that make writing a book possible, from those who are responsible for printing, publishing and marketing the book to those we interviewed and depended on to point us in the right direction for research material. It would take a better prose than ours to express our heartfelt feelings of gratitude to each and every person who provided us assistance. But we will try.

Ben Gibson, at The History Press, was always there to answer our questions and had faith that our collective knowledge of local history and paranormal subjects would benefit the project. We also want to thank all those behind the scenes at The History Press who make us look good. Thank you!

Ernie LaPointe, great-grandson of Chief Sitting Bull, educated us about Native American culture and told us some of the fascinating oral history of his ancestors. It was a true honor. And thank you Ernie for your service to our country.

Our friends at the Adams Museum and House—Mary Kopco, director of the Adams Museum and House; Hayley Chambers, curator of the Adams House; and Rose Speirs, communications director of the Adams Museum and House—provided an incredible amount of information that directly influenced us and the success of this project. Thank you for your support and friendship.

We were truly appreciative of the friendly staff at the Deadwood Library for providing us with professional, helpful and friendly assistance. They were always willing to answer questions and help us figure out how to work the infernal microfilm machine.

Acknowledgements

Ron Russo, owner of the Fairmont Hotel, is not only a businessman, but he is also a true and passionate historian at heart. His knowledge of Deadwood history was invaluable to us. Ron is quite the character, and if you have an opportunity to visit Deadwood, stop in, belly up to the bar and say hi. We guarantee that you will not be disappointed.

We would also like to thank the members of the staff of the Bullock Hotel for their eagerness in telling us their stories and for allowing us to roam the hotel. We want to especially thank Molly VanNorman, who provided us with some great stories. If you ever visit the Bullock Hotel, make sure you take her guided haunted tour of the hotel.

A special thank-you goes to the staff at the Lucky Nugget Casino, especially Charles, who allowed us to once again roam the haunted second floor.

We also want to thank our Black Hills Paranormal Investigations teammates Mark Rowland, Susan Parsons, Maurice "Mo" Miller, Peggy Shadley, Dustin Hallett and Charles and Rachel Blanchard. We are lucky and proud to be associated with this group of common-sense paranormal investigators.

Last but not least, we want to thank our beautiful wives, Peggy and Amanda, for being there every step of the way. We love you!

INTRODUCTION

As the coolness of the fall night seeped through the loose-fitting windowsills covered with layers of peeling paint, we stood motionless in the darkness of what were once the lively and raucous brothels of Deadwood's "Badlands." We all heard it, but we were by no means willing to admit it until someone else in the group spoke up first. Once one of us mentioned that they just heard a female voice, a chorus of "I heard that, too!" broke the silence. We had just experienced a disembodied ghostly voice. This experience was just one of many we encountered while investigating the second floor that once housed the infamous brothels of Deadwood, South Dakota.

Whether conducting paranormal investigations in the Badlands of Deadwood's lower Main Street or at a private residence situated precariously on the side of the steep hillsides overlooking town, one thing remains constant. Deadwood's history is palpable. It becomes clearly evident that the historic present-day buildings on Main Street were not built with the intent to amuse or entertain tourists. These buildings were built on the burned-out foundations of an early Deadwood. They were built with purpose and a function.

Walk down Main Street, and you can feel the energy of an earlier time, when Deadwood streets were crowded with freight wagons pulled by oxen and the yell of the teamster and crack of the whip filled the air. Take a deep breath, and you can almost smell the whiskey, manure, Chinese incense and opium wafting through the streets. You can almost hear the faint gunshot that killed "Wild Bill" Hickok or the sounds of laughter

Introduction

and music coming from the popular Gem or Bella Union Theaters. This energy has no doubt permeated the environment, and that is why, to this day, we hear stories of ghostly figures looking down from the windows of the brothels and listen to eerie tales of shadow figures ducking into the nooks and crannies of buildings.

As paranormal investigators, we have always been intrigued by the symbiotic relationship between claims of paranormal activity and historical events. We would be remiss not to admit that we are always searching for that ever-elusive answer to the question of the ages: what are ghosts? We may never be able to adequately explain or answer this question with absolute conviction. We do believe, though, that those of us in the paranormal trenches can at least give an intelligent answer, through proper historical research, to the second most frequently asked question: why are certain structures or geographic areas prone to paranormal activity?

All too often, some people in our field tend to not only glaze over the historic background of a structure or geographic area but also completely overlook the history of the haunting activity itself. They are looking instead for that one piece of documentation of a reported death or some violent activity. Once that small piece of the story is collected, most feel that they have the essentials to properly answer the question of why. To be sure, death and violence are inextricably linked to our field and are often great companions to a successful telling of a ghost story. If hauntings are a result of energy imprinting on the environment, then it would stand to reason that strong emotions, such as happiness and love, can certainly imprint their energy on an environment, too. So, paranormal investigators should not just look for death and violence but rather at the whole picture. What does the whole story tell us? We are not defined by just the tragedy and death in life. We are defined by the sum of our experiences, good and bad. It makes us who we are.

In the following chapters, we will focus on the history of the Black Hills and Deadwood through the eyes of the original inhabitants of the area, as well as current residents. We will discuss and explore the history of Deadwood's hauntings. We will take you along with us on paranormal investigations into some of Deadwood's most notorious locations, such as the brothels and the site of Wild Bill Hickok's killing. We will explore museums that were once private residences of well-known Deadwood entrepreneurs of yesteryear. We will delve into the histories of these locations and the stories of the hauntings themselves. We will discuss little-known tales and secrets of a Deadwood that no television show has ever explored.

Native American Ghost Stories of the Black Hills

As a preface, this chapter uses some terminology that is Lakota rather than English. Translating this language into English is very difficult as there's not an exact word-for-word translation. The same also applies to the spelling of these words. The Lakota people and their language, much like their history, is oral or spoken word. The spelling of these words is based on phonetics by the authors.

With the Black Hills of South Dakota having been a spiritual epicenter for the Native American people, we would be remiss not to speak about the spiritual attachment that these people have with the area. Despite inhabiting the surrounding area, the Lakota people did not venture into the Black Hills very often. The land is considered sacred, believed to be the "heart of the turtle island." The "turtle" refers to North America, with the Black Hills being the center (or "heart"). The land was used as a sacred burial ground and was also reserved for special ceremonies.

A pair of geographical landmarks surrounding the Black Hills reveals a look into the spiritual connections to the area for the Lakota people. One Lakota creation story tells about seven young girls being chased by a great bear. The girls fled, praying to the creator to protect them from the bear. The creator responded and made a massive tree rise beneath them to protect them from the bear. The bear began clawing in vain at the tree to reach the girls, but the tree continued growing higher and higher. The girls ultimately reached the sky and were turned into the constellation known today as the Pleiades. Exhausted, the bear left and found a spot to lie down to sleep. The

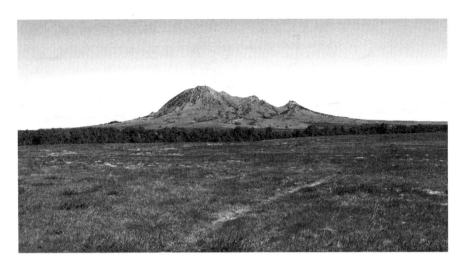

Bear Butte, "heart of the turtle island" for the Lakota people. *Photo by Mark Shadley.*

bear never rose again and became a permanent fixture of the topography of the Black Hills. *Matho' Paha'* ("Bear Mountain" in Lakota) is known today as Bear Butte, located outside Sturgis, South Dakota. The tree that ultimately saved the girls also became a part of the earth, known as Devils Tower.

The authors have the incredible honor of being friends with Earnest (Ernie) Wayne LaPointe. Ernie is the great-grandson of Sitting Bull and one of his wives, Seen By Her Nation. Ernie was born on the Pine Ridge Indian Reservation of South Dakota. At the age of eighteen, Ernie joined the military and served for six years, including one tour in Vietnam. Ernie has chosen to live the traditional Lakota way and follows the rules of the sacred pipe as a sun dancer. Ernie has assisted in the creation of several television documentaries and books. Ernie also has produced DVDs telling the story of Sitting Bull as it was passed down to him. Ernie assisted in our paranormal investigations by interpreting EVPs (electronic voice phenomena) that were found to be Nakota (a dialect of the Lakota language). Much of the information in this chapter came from Ernie's incredible storytelling. Ernie described two types of spirits commonly encountered:

> *The Lakota have their own beliefs when it comes to the paranormal. They believe in two different types of spirits. The first type is known as a* Tunkan. Tunkan *are widely regarded as positive and helpful spirits. These were good people in life who learned to balance their spirit, mind, heart and body. Upon death, they made the journey to the spirit world.*

A True Wild West Ghost Town

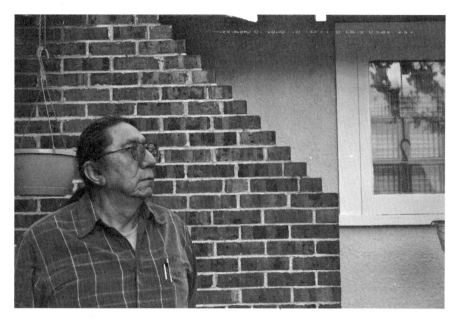

Ernie LaPointe, great-grandson of Chief Sitting Bull. *Photo by Mark Shadley.*

Their spirit was accompanied by their spirit guide to the spirit world. Tunkan *are able to travel freely between our physical world and the spirit realm.* Tunkan *come to people in visions often and help them.* Tunkan *are appeased by offering food and tobacco. They don't eat in the way we think, but rather by scent.* Tunkan *are obedient; they help when given an offering and do as they are asked.* Tunkan *are known to specifically target women.*

The other type of spirit is known as a **Wanugi***. This spirit is generally filled with jealousy and greed in life. Often times, these spirits don't know that they have died as their death was tragic and sudden. Other times, they do know they have passed on, but are not aware that the journey to the spirit world would benefit them.* Wanugi *are viewed as deceitful and misleading, generally mischievous.* Wanugi *generally come out during the New Moon phase, when the Lakota believe the moon dies. Lakota are told to avoid going outside during the new moon for this reason.*

Ernie said, "If you encounter a *Wanugi*, you may not see anything, but you will smell the scent of sulfur or rotten eggs. This is dangerous, because you don't want the *Wanugi* to touch you." He went on to say this about *Wanugi* spirits:

Maybe a spirit says to these Wanugi *in the native tongue "come with me" and the* Wanugi *doesn't understand and cannot make the journey to the spirit world. Maybe that's why they haunt places, why they become attached to things or places. It's something that you need to understand, not to be attached to physical things, or that can lead you to become a* Wanugi.

The Lakota engage in a ritual known as "smudging." This practice refers to the binding of sage sticks together and burning them. The smoke that is produced is used to cleanse. *Tunkan* are attracted to the smell of sage being burnt. *Wanugi*, on the other hand, do not like the smell of sage, and it repels them. Smudging is common in other belief structures as well, being practiced in medicinal and religious situations.

Another means of protecting the soul or spirit was the practice of warriors painting their faces and bodies before battle. LaPointe pointed out that the practice of painting the body was meant to protect the warrior's spirit if killed in battle; it was not intended as "war paint," as many believe.

LaPointe told a story about going to Washington, D.C., to reclaim some artifacts from the Smithsonian Institute that had belonged to his great-grandfather, Chief Sitting Bull, and returning home with more than he bargained for. The Smithsonian invited LaPointe to claim what belonged to his family. When he arrived, he smoked a traditional pipe and prayed in order to find his great-grandfather's belongings. When he prayed, he saw an eagle, his spirit guide, which landed on objects belonging to Sitting Bull.

LaPointe also brought with him a Lakota medicine man to assist during the ceremonies at the museum. On the flight home, the medicine man confided to LaPointe that some of the spirits that were in the museum were also on the plane with them. The medicine man told him that there were hundreds, maybe even thousands, of spirits in the museum during their visit. The man told LaPointe that they had opened a gate while in the Smithsonian and that about 250 to 300 of these spirits were following him to his home in Lead, South Dakota. He told LaPointe that when he got home he should give the spirits offerings of food. When he arrived home, LaPointe described hearing all sorts of noises in the home, as if there were many other people there. LaPointe knew that he was not alone and continued to hear and experience walking and talking and even singing throughout the home. LaPointe's wife, Sonja, made a plate of food for the spirits from every single meal they had in the home as an offering. After about a week, the medicine man told him to ask the spirits if they'd agree to go to the spirit world. LaPointe conducted a ceremony, asking for his own spirits to guide the lost spirits to Bear Butte so

that they could find their way to the spirit world. Soon, the spirits started to leave, and soon the strange noises in the home began to subside.

It was a bittersweet experience for both Ernie and Sonja. They were slowly getting their home back to normal; however, they had grown accustomed to the spirit visitors, so it was a bit of an adjustment. When asked why all of the spirits didn't follow him home, Ernie pointed out the fact that opening and closing the door at the Smithsonian was like a vortex at the time—a passage door had only temporarily been opened. He did express sadness for the spirits still there, citing the joy that he received from helping the spirits that did follow him home. Ernie stated that the spirits at the Smithsonian were attached to these objects because the objects often weren't given away—they were taken. This meant that the spirits had not been freed from their attachment.

Ernie went on to say that if you get attached to a house and then pass on, you're still attached to that house. If someone goes and remodels it, that energy is still there. At that point, you unleash a spirit, and the spirit isn't happy to see its home change. This leads to an interesting parallel to the paranormal investigation field. It is common to see paranormal activity pick up or become more prevalent when remodeling or when any changes are made.

Even the creation story of the Lakota people is incredibly spiritual. The Black Hills are called the heart of the turtle island. When we asked what that meant, LaPointe related the following story to us:

> *The creator was on his buffalo robe after the giant flood, floating on top of the water with his pipe. A bird was flying nearby. Some say it was a crow, others say a hawk or eagle that was flying. There was no land, and the bird yelled down that he needed a place to land. The creator reached into his bag and pulled out a loon and told the loon to dive down and pull up some mud. The loon came back up and said that it could not see the bottom. Next, the creator pulled out the otter and the otter was gone a little longer and said that it could not see the bottom. The creator pulled out the beaver and said to use your flat tail to propel yourself to the bottom and bring me some mud. The beaver was gone a little while and came back to say it could see the bottom but was unable to get to it. The creator pulled out the turtle and tasked him the same. While the turtle was gone, the other animals and the creator began to sing songs. The loon told the creator that the turtle must have died. Then the turtle broke the surface with mud covering the claws and shell. The creator used this mud to create land and man.*

The story of the Black Hills also has an amazing story from the Lakota. The Black Hills were host to a race between the two-legged creatures and the four-legged creatures to see who would be allowed to consume the other. The buffalo was winning the race, but unbeknownst to the buffalo, a magpie was sitting on its horns. At the last second, the magpie flew forward and won the race for the two-legged creatures, which is why man now eats the meat of animals.

LaPointe not only experienced paranormal activity in his own home but has also encountered his fair share in other locations. LaPointe told of an experience he had at the Fairmont Hotel, which is discussed in a later chapter. While at the Fairmont, he was near where the slot machines are now, and as he was looking at a machine, he saw movement in his peripheral vision. He looked up and saw a woman walk up a staircase through a chain blocking the entrance. LaPointe asked about the female he had seen but was told that there was no one there by that description. LaPointe described the female apparition as wearing a white top and either wearing a hat or sporting a tall hairstyle.

LaPointe also described another paranormal experience he had while in Deadwood:

> *I never get shocked by spirits, but I did one time at the Gold Dust in Deadwood. I was in the bathroom, I was washing my hands and I felt a guy standing there by the towels. I saw him clearly in my peripheral vision; he was wearing a white shirt and black pants. I looked back into the mirror, and he wasn't there. I came out of the bathroom, and Sonja looked at me and asked what was wrong; I told her I had just seen a ghost.*

Clearly, the Black Hills is a mystical and spiritual center of the Native American culture. The rich and powerful tales handed down from generation to generation reveal that ghost stories are prevalent in every culture of the world. The Lakota have the *Tunkan* and *Wanugi*. We have good and evil spirits. Either way, it is clear that there are many similarities that have crossed the cultural gap. It would seem that ghost stories are similar no matter what culture you are from.

BLACK HILLS HISTORY

Any topic of discussion related to the Black Hills is incomplete without including some mention of its incredibly significant history. One chapter cannot truly capture the richness of that history, so this is not intended to do so. Our challenge was not so much providing the reader with a considerably condensed version of that history; rather it was making sure that we provided a balanced and accurate history of the Black Hills in a condensed version. We hope that we succeeded in our efforts and properly conveyed the spirit of the Black Hills.

Appearing like a dark ghostly mirage on the rolling prairie, the Black Hills emerge out of nothingness like an island rising from the surface of a great ocean. Known to the Lakota Sioux as Paha Sapa, the Black Hills derive their name from the dark appearance that the ponderosa pines give the Hills when viewed from a distance. The Black Hills, primarily situated in western South Dakota, are about one hundred miles long and sixty miles wide. This island of granite, limestone and pine contains the highest peaks east of the majestic Rocky Mountains and was at the center of bloody conflict among native tribes long before the United States won its independence from England.

In the early 1600s, the Chippewa began migrating west from their lands, driving the Lakota and Dakota Sioux tribes inhabiting the area of present-day Minnesota into the Missouri River Valley. This westward migration of the Sioux would have a domino effect on other tribes living along the Missouri River by way of driving those tribes from their ancestral hunting grounds. The Mandan, Hidatsa and Cheyenne, being threatened by the

The Black Hills as they appear from a distance. Center is Harney Peak, highest point of the Black Hills. *Photo by Mark Shadley.*

Sioux's migration, would eventually relocate, bringing them into conflict with the tribes inhabiting the Black Hills area.

In the early 1700s, the Cheyenne defeated the Crow, Kiowa and Arapaho tribes inhabiting the regions surrounding the Black Hills. The Sioux, now occupying the lands east of the Missouri River, took advantage of a smallpox epidemic decimating tribes living on the west bank and began moving into the rolling prairie lands west of the Missouri River. In 1776, the year of American independence, Chief Standing Bull of the Oglala Sioux defeated the Cheyenne tribes occupying the Black Hills region, pushing them farther west and out of the Dakota territories. By the early 1800s, the Lakota Sioux had effectively forced out all other tribes and controlled the area around the Black Hills. However, unknown to the Sioux and other tribes, a much larger and stronger opponent was lurking on the horizon that would soon fix its attention on their lands and forever change the Native American way of life.

By the mid-nineteenth century, the United States had expanded its control of lands from the Atlantic to the Pacific. Many Americans supported this expansion through the guiding principle of Manifest Destiny. However, this policy of expansionism and an ensuing economic depression brought

A True Wild West Ghost Town

about deadly confrontations between the United States and native tribes occupying these lands.

During 1866–68, the United States was embroiled in an all-out war with Chief Red Cloud, an Oglala Lakota Sioux, over westward expansion on the Bozeman Trail. The United States had established forts along the Bozeman Trail to protect migrant settlers traveling to the Montana gold mines and points west. As this was an infringement on traditional Sioux, Cheyenne and Arapaho hunting grounds, Red Cloud went to war with the United States. Red Cloud successfully laid siege to the forts along the Bozeman Trail, forcing the United States to sue for peace. The Fort Laramie Treaty of 1868 was the result of this war, and the treaty effectively shut down the Bozeman Trail and closed the forts protecting the trail, as well as established a great Sioux reservation that included the Black Hills. This was the first and only war the Native Americans would win against the United States Army. In less than ten years, however, the government would nullify the Sioux's rights, and the Black Hills would be populated with thousands of gold seekers and settlers.

The economic depression of 1873 struck the United States hard. Banks and railroads went bankrupt, soon followed by farmers who depended on loans from the banks and on railroads to haul their harvests; millions of people were out of work. Rumors were floated that the Black Hills land had unlimited mineral and lumber resources; this was exactly what the United States needed to infuse an anemic economy. One obstacle stood in the way of civilian exploration into the Black Hills region: the Fort Laramie Treaty of 1868 forbidding white encroachment into the Black Hills. Earlier attempts to explore and map the Black Hills interior by the military had been thwarted by the Sioux, citing tenets of the Fort Laramie Treaty and threatening all-out war. No one knew what mysteries the interior of the Black Hills held; it was quite literally a blank spot on the map. However, changing political policies and the economic depression ensured that the Black Hills would receive the undivided attention of the American government.

In 1874, Lieutenant Colonel George Armstrong Custer was ordered to lead a military expedition into the Black Hills with two objectives: locate a suitable location for a military installation to enforce treaty policies of the Fort Laramie Treaty and assess the mineral value of the Black Hills for future purchase from the Native American tribes. Based on the articles of the Fort Laramie Treaty, the United States government was arguably justified to enter the Black Hills to make appropriate assessments; however, as mentioned earlier, previous attempts to enter the Hills were met with

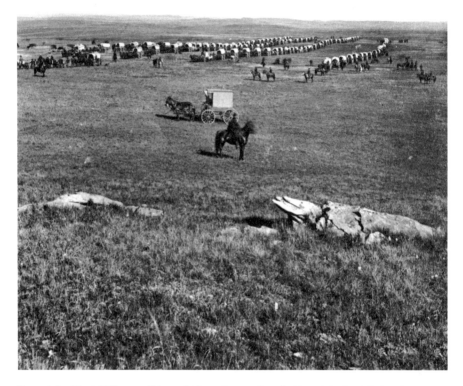

Part of the Black Hills expedition of 1874. *Courtesy State Archives of the South Dakota State Historical Society.*

resistance and threats of war. No one knew for sure if an expedition into the Black Hills would provoke a violent response from the Sioux and other tribes. So, to ensure that the expedition was properly protected, Custer assembled a formidable contingent of 1,200 men, 110 wagons and 300 cattle to feed those men. If any Indians in the area saw the massive column of men and equipment, they would think twice about engaging such a large force. As it turned out, Custer and his men were never molested or threatened by Indians on this trip.

As Custer approached the Black Hills, he had no idea how or where he would traverse the interior. Custer's own Indian scouts advised him to

A True Wild West Ghost Town

abandon his wagons if he were to have any chance at all of successfully entering the Hills. Custer was facing the problem of the era: there were plenty of maps depicting the surrounding landscape, but none revealed the interior. Eventually, Custer forged a route that would take the expedition through to the interior of the Hills and lead them to French Creek near present-day Custer, South Dakota.

On August 2, 1874, while in permanent camp on French Creek, prospectors with Custer's expedition discovered gold in paying quantities. Custer sent "Lonesome Charlie" Reynolds to make the dangerous ride to Fort Laramie with the news that the country and the world were waiting to hear: gold had been discovered in the Black Hills! Custer's expedition was

Custer campsite near present-day Custer, South Dakota. Gold was discovered near this point on French Creek in July 1874. *Courtesy State Archives of the South Dakota State Historical Society.*

barely out of the Black Hills when plans were underway by gold seekers to make the long, dangerous and illegal journey to the Black Hills. It is interesting to note that once gold was discovered, Custer completely ignored the edict of his superiors to scout out a suitable location for a military fort, and his survey of mineral riches lacked substance. It has been argued that Custer's primary goal was to simply find and map a route to the interior of the Hills and confirm the existence of gold. Either way, the Lakota later came to call Custer's trail to the Black Hills the "Thieves' Road."

As a result of gold discoveries in the Black Hills and the constant, unchecked violations of the Fort Laramie Treaty of 1868, war was inevitable, and in 1876–77, the Great Sioux War (or Black Hills War) was fought for ownership of the Black Hills. One of the most famous battles of western history was fought during this conflict when George A. Custer and more than 260 men of his vaunted Seventh Cavalry died at the battle of the Little Big Horn in southeast Montana Territory on June 25, 1876. This was the army's largest loss of men in a single day of battle since the Civil War. Many of the men who died that day with Custer were veterans of the Black Hills expedition, including the messenger Charlie Reynolds. Could this defeat of Custer and the Seventh Cavalry have been a result of angering the great spirit of the Black Hills? Either way, this was a great victory for the Native Americans; it would, however, sadly be the beginning of the end of their nomadic way of life. In less than twenty-five years, the great tribes of the Plains Indians would be nothing more than a memory, and white settlement would be firmly entrenched in the Black Hills.

Deadwood History

Soon after the Custer expedition left the Black Hills and the announcement was made to the world that gold had been discovered, there were hundreds if not thousands of illegal trespassers in or on their way to the Black Hills—so many, in fact, that the United States Army had great difficulty enforcing the tenets of the Fort Laramie Treaty by keeping trespassers out of the Hills. Many gold seekers, those able to successfully avoid army patrols, established profitable placer mining operations throughout the Hills. Some of the most successful and

A True Wild West Ghost Town

Early Deadwood street scene, roughly one month before the arrival of Wild Bill Hickok and Calamity Jane. *Courtesy Deadwood History, Adams Museum Collection, Deadwood, South Dakota.*

profitable operations would soon be discovered at the intersection of two creeks situated in a narrow, overgrown gulch littered with dead trees.

By late 1875, Deadwood (named for those dead trees lying about) was populated by just a handful of gold miners. By early 1876, Deadwood's Main Street had been laid out, with buildings built virtually overnight. The June 24, 1876 edition of the *Black Hills Pioneer* described the scene:

> *We do not believe this or any other country affords such another example of rapid development as what is now known as "The Deadwood Country." Three months ago it was occupied by only a few hardy miners—scarce fifty in number—who had placed their lives in peril, both from Indians and starvation, living on "meat straight," without even salt, for months, and undergoing nearly every privation known to man in search of the precious metal. Now Deadwood, Whitewood, and their tributaries, are peopled by more than seven thousand of as hardy, energetic and intelligent men as there are in the country: men who have left home, wife and children, and endured hardships and incurred dangers that those in the States little dream of, in search of a better country—more money. They have found it, and today, go*

> *where you will, the sound of the pick, shovel, rocker and sledge greets your ear, and sluice-boxes, ditches and dams are on every hand.*

Although illegally settled, Deadwood was on the map, and a sense of community and legitimacy was spreading throughout the camp. Deadwood was attracting a diverse yet hopeful segment of the population looking to start a new life. Some came to Deadwood for reasons other than digging in the dirt—soiled doves (prostitutes), gamblers, confidence men and swindlers. These were the dregs of society who lived on the edge of an ever-expanding United States, taking advantage of lawless towns and unwitting victims. Many of the first businesses opened in Deadwood were saloons and brothels, built to entertain the miners, many of whom worked grueling sixteen-hour days. All too often, the miners would work long hours digging for gold and wind up losing it all gambling, drinking and entertaining women.

It could be said that Deadwood was two diverse towns fighting for survival. One was the young, wild, illegal and lawless gold camp where anything goes; the other saw the development of a legitimate, successful mining town and an important transportation and supply hub. Estelline Bennett, author of *Old Deadwood Days*, had an interesting conversation with William "Buffalo Bill" Cody over this point when the railroad finally came to Deadwood:

> Buffalo Bill…told me he was not surprised at the changes he found because railroads always aged a town. "A town is young," he said, "just as long as it stays off the railroad."
> "It's too bad the railroad came," I commented.
> "Oh, no," he said quietly but decidedly, "a town is like a baby. It either grows up or dies." And then he added with ready optimism of the real Westerner, "But Deadwood, you know, was young so long it never will quite forget its youth."

Famous Deadwood Deaths: James Butler "Wild Bill" Hickok

In July 1876, James Butler "Wild Bill" Hickok rode into Deadwood with Colorado Charlie Utter's wagon train, along with Martha "Calamity Jane" Canary at their side. Wild Bill had recently married Agnes Lake, a circus

A True Wild West Ghost Town

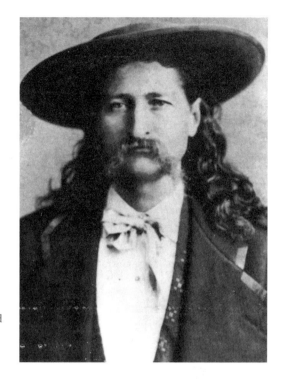

James Butler Hickok, better known as "Wild Bill," will forever be inextricably linked to Deadwood and the "Dead Man's Hand." *Courtesy Deadwood History, Adams Museum Collection, Deadwood, South Dakota.*

performer, and came to Deadwood to take advantage of the gold rush and make a little money prospecting. He instead found the gambling tables more inviting and less strenuous work. Throughout the short time he was in Deadwood, an overwhelming premonition of death haunted him. Wild Bill confided to his friend Charlie Utter that he thought he would never leave the Hills alive. On August 1, 1876, the day before his death, he wrote a poignant letter to his wife that reinforced the belief that he knew his days were numbered:

Agnes Darling,

If such should be we never meet again, while firing my last shot, I will gently Breathe the name of my wife—Agnes—and with wishes even for my enemies I will make the plunge and try to swim to the other shore.

J.B. Hickok
Wild Bill

On August 2, 1876, while playing poker at Nutall & Mann's Saloon #10, Wild Bill's disconcerting premonitions came true. He reluctantly sat

with his back to the door as his normal seat was taken and the person sitting there refused to give up the seat. As the game progressed—it is said that Wild Bill was holding two-pair, aces and eights—Jack McCall, a drifter and a person known more for his drunkenness and stupidity, slowly worked his way behind Wild Bill and shot him in the back of the head with his .45. Wild Bill died instantly, holding what would be forever known as the "Dead Man's Hand." Soon after Wild Bill's death, the *Black Hills Pioneer* newspaper described the details of that deadly day:

> *We found the remains of Wild Bill lying on the floor. The murderer, Jack McCall, was captured after a lively chase by many of our citizens, and taken to a building at the lower end of the city and a guard placed over him. As soon as this was accomplished a coroner's jury was summoned, with C.H. Sheldon as foreman, who after hearing all the evidence, which was to the effect that while Wild Bill and others were seated at a table playing cards, Jack McCall walked in and around directly back of his victim, and when within three feet of him raised his revolver, and exclaiming "Damn you, take that," fired, the ball entering at the back of the head and coming out at the centre of the right cheek, causing instant death, rendered a verdict in accordance with the above facts. Preparations for a trial were then made by calling a meeting of citizens at the theatre building.*

The reporter went on to describe the speedy trial and acquittal of Jack McCall in the same article:

> *[T]he gentlemen present numbering 100, elected Judge Kuykendall to preside at the meeting as judge in the trial of the cause. Isaac Brown was elected sheriff, and one deputy and twelve guards were appointed. It was then decided to adjourn to meet at 9 o'clock A.M. Thursday, Aug. 3d...At nine o'clock Thursday the meeting was called pursuant to adjournment...Col. May was chosen prosecuting attorney, and A.B. Chapline was selected by the prisoner, but owing to sickness Mr. Chapline was unable to attend, and Judge Miller was chosen in his place...The evidence in the case was the same as that before the coroner's jury, so far as the prosecution was concerned. The defense was that the deceased, at some place in Kansas, killed the prisoner's brother, for which he killed deceased. The jury, after being out an hour and thirty minutes, returned the following verdict: Deadwood City, August 3, 1876. We the jury find Mr. John McCall not guilty.*

A True Wild West Ghost Town

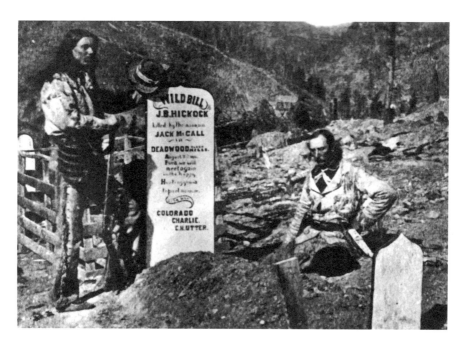

Charlie Utter (kneeling) and Arapahoe Joe tending to Wild Bill Hickok's grave at the Ingleside Cemetery. *Courtesy Deadwood History, Adams Museum Collection, Deadwood, South Dakota.*

As McCall's Deadwood trial was being held, Charlie Utter was burying Wild Bill in Deadwood's Ingleside Cemetery. Charlie, a longtime friend, inscribed a typical western epitaph on Wild Bill's wooden tombstone:

Wild Bill
J.B. Hickock
killed by the assassin Jack McCall
in Deadwood Black Hills
August 2nd 1876.
Pard we will meet again in the
Happy Hunting Grounds to part no more
Good Bye
Colorado Charlie Utter

After the trial, McCall left Deadwood for Wyoming Territory, where he began bragging how he was the one who killed the great Wild Bill Hickok. This apparently did not sit well with Wyoming officials, who promptly arrested

McCall and sent him to Yankton, the capital of the Dakota Territory, to be tried for the murder. During the trial, it was argued that McCall had already been tried and found not guilty by a jury. Unfortunately for McCall, double jeopardy did not apply as the original trial had occurred outside of United States jurisdiction. McCall was promptly found guilty and hanged on March 1, 1877. He was buried with the noose still tightly secured around his neck.

In 1879, a building boom was encroaching on the Ingleside Cemetery property, and a decision was made to move all grave sites farther up the hill to Mount Moriah. Wild Bill's remains were exhumed and moved to Mount Moriah Cemetery by his friend Charlie Utter. John S. McClintock, an original pioneer of Deadwood, was one of the men who helped Utter rebury Wild Bill's remains. After arriving at the new grave site, McClintock described what happened next:

> *Here the box was opened and the lid of the casket was removed. The body down to the hips was exposed. To our great astonishment it appeared to be in a perfect state of preservation. Being perfectly white, it seemed to have a coat of lime finish. The clothes, which were decomposed, had evidently been jolted to the sides while in transit to the new grave, leaving the upper portion of the body exposed. The manifold pleats in the fine linen shirt which he wore showed plainly on his form.*

McClintock went on to describe, very matter-of-factly, how he went so far as to poke Wild Bill's body with a stick, discovering "no soft places anywhere" and likening the sound the stick made on the body to that of tapping on a wall.

Famous Deadwood Deaths: Martha "Calamity Jane" Canary

After Wild Bill's death, Calamity Jane stayed in Deadwood for a short while and told anyone who would buy her a drink how she and Wild Bill had been secret lovers. (This claim has never been proven.) Although she was a rough character, often rougher than some men, it surprised many to see that she did have a soft side, which was demonstrated in 1878 when a smallpox epidemic hit Deadwood. While others stayed clear of those infected, she spent countless hours with the sick, helping to nurse them back to health without any concern for her well-being.

A True Wild West Ghost Town

Calamity left the Black Hills for a time. However, she showed up when least expected and indulged in drinking binges with old friends. On August 1, 1903, just one day shy of the twenty-seventh anniversary of Wild Bill's death, Calamity Jane died from complications of alcoholism just up the road from Deadwood in the small town of Terry, South Dakota. The word was passed around that her last request was to be buried next to Wild Bill, and the request was honored. To this day, Calamity Jane lies in eternal rest next to Wild Bill Hickok in Mount Moriah Cemetery.

When Wild Bill and Calamity Jane rode into Deadwood on that hot July day in 1876, there were many who did not care for their lifestyle or the fact that they were even in Deadwood at all. They did not come to set down

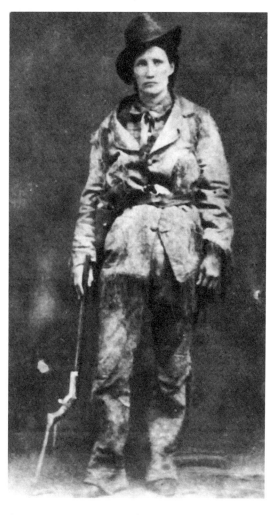

Calamity Jane, image taken in 1876 while in Deadwood. *Courtesy Deadwood History, Adams Museum Collection, Deadwood, South Dakota.*

roots or build their homes here. They did not come to contribute anything substantial to the success of Deadwood. It could reasonably be argued that they came for entirely selfish reasons, to promote their fame. The once open and wild American West was slowly being tamed. Wild Bill and Calamity Jane represented a dying breed of rough characters living on the fringe who came to depend on this open lifestyle. Deadwood was truly that last vestige of the American Wild West that they had come to revere, and the final chapters

of their lives would forever be intertwined with Deadwood's history. Today, hundreds of thousands come to visit Deadwood to walk the streets that Wild Bill and Calamity Jane walked and to visit their Mount Moriah grave sites. It seems that in the long run, in their own way, these two western icons did contribute something to Deadwood's continuing success.

Early Deadwood Hauntings

Wild Bill's murder in Nutall & Mann's Saloon #10 is the most famous celebrity death in Deadwood's history. Many tourists come to Deadwood to see where the "Prince of Pistoleers" was killed and hopefully experience an encounter with Wild Bill's spirit. This task might be tougher than most think, as many of the original locations, including Saloon #10, burned to the ground in the great fire of 1879, and any records of the original locations of these establishments have long been lost. The current site of the Eagle Bar, now closed, is popularly considered the closest site to where the original #10 was located. However, the owner of the Fairmont Hotel, Ron Russo, established the original site of saloon #10 to be in his back parking lot. Wherever the site is located, our research revealed that no one has ever claimed that Wild Bill's ghost haunts any of these locations.

There are, however, several establishments lining Main Street today that experience their share of strange stories of paranormal activity. The Badlands of early Deadwood was an active and deadly place where many lost their lives, including prostitutes who either took their own lives or were killed by their clients. On December 6, 1877, Kitty LeRoy, a popular dancer, faro dealer and probable prostitute, was shot and killed by her jealous husband, who afterward turned the gun on himself. The first reported haunting in Deadwood might have been as a result of this double killing, as reported in a *Black Hills Daily Times* article dated January 16, 1878, under the headline "Haunted House":

> *For some time past vague rumors have been in circulation concerning unnatural and unaccountable noises and apparitions in the "Lone Star" building on lower Main street, near Chinatown. This house will be remembered by Deadwoodites as the recent scene of the murder of Kitty LeRoy, and the subsequent suicide of her murderer and husband, Sam. R. Curley. These reports having become a subject of general conversation,*

A True Wild West Ghost Town

> *a TIMES reporter visited the house, of which so many stories were afloat, and gleaned the following: The Lone Star building gained its first notoriety from the suicide, by poisoning of a woman of ill repute last spring. The house was subsequently rented by Hattie Donnelly, and for a time all went smoothly, with the exception of such little rows and disturbances as are incident to such places. About the first of December the house was rented by Kitty LeRoy, a woman said to be well connected and possessed of intelligence far beyond her class. Kitty was a woman well known to the reporter, and whatever might have been her life here, it is not necessary to display her virtues or her vices, as we deal simply with information gleaned from hearsay and observation. With the above facts before the reader we simply give the following, as it appeared to us, and leave the reader to draw their own conclusions as to the phenomena witnessed by ourselves and many others. It is an oft repeated tale, but one which in this case is lent more than ordinary interest by the tragic events surrounding the actors.*
>
> *To tell our tale briefly and simply, is to repeat a story old and well known—the re-appearance, in spirit form, of departed humanity. In this case it is the shadow of a woman, comely, if not beautiful, and always following her footsteps, the tread and form of the man who was the cause of their double death. In the still watches of the night, the double phantoms are seen to tread the stairs where once they reclined in the flesh and linger o'er places where once they reclined in loving embrace, and finally to melt away in the shadows of the night as peacefully as their bodies' souls seem to have done when the fatal bullets brought death and the grave to each.*
>
> *Whatever may have been the vices and virtues of the ill-starred and ill-mated couple, we trust their spirits may find a happier camping ground than the hills and gulches of the Black Hills, and that tho' infelicity reigned with them here happiness may blossom in a fairer clime.*

The Lone Star building was later swept away in the 1883 flood, and any city records that fix the true location of the building have long since been destroyed in the fires and floods that plagued Deadwood. However, based on early reports, the Lone Star building was located on lower Main Street near Chinatown.

Another interesting haunting case came to light when the *Black Hills Daily Times* reported in October 12, 1888, that the ghost of a woman was haunting a house located near the Deadwood Street Bridge. It also noted that the Chinese population that lived in this neighborhood reported that this same female ghost took on the form of a goose that would haunt their

homes. In an effort to prevent this ghostly phantom from entering their homes, the Chinese citizens placed slices of apples on their doorsteps as an offering. This small gift seemed to appease this spirit, as the apples were gone from their doorsteps in the mornings and no spirits were reported to haunt their homes.

One interesting report mentioned that those living near Whitewood Creek and Siever Street reported hearing this same ghost speaking outside their homes at night, demanding to be fed. The *Black Hills Daily Times* reported on an impromptu investigation by some early Deadwood ghost hunters: "The Siever Street ghost has not been heard of lately. A party of ladies has been on the watch for several nights for that purpose of hearing the other side, but it appears his spookship seems to be taking a rest."

Could it be that an enterprising live soul saw an opportunity for a free meal and simply took advantage of the superstitious? It seems in this case that the reporter had his suspicions.

There is no doubt about one thing. Deadwood's wild past and reputation have indelibly imprinted its energy on the environment—it is as palpable today as it was when the town was first settled. This energy draws throngs of visitors each year to this iconic Old West town in the hopes of experiencing the Deadwood of yesteryear. And just maybe, if you are lucky, you might run into a ghost of a past resident.

THE BROTHELS

For a new and remote camp such as Deadwood is, the number and quality of ladies is remarkable. True, there are many females of another set, and they ply their vocations with an assurance and audacity that is seldom seen elsewhere, but the proportion in which they stand to the noble, virtuous women of Deadwood, will compare favorably with the average city, and is certainly very creditable to her.
—*"Cheyenne Leader"* (Black Hills Daily Times, May 1, 1877)

Early settlers in Deadwood did whatever they could to make a living or even just survive. While some dug for gold, others started businesses that were pivotal to Deadwood's boom as a town. Still others found their calling with more nefarious occupations. As expected, there were gamblers, swindlers and thieves. One of the most well-known occupations is described as the oldest profession in the world. Prostitution in Deadwood quickly became a business opportunity for those who decided to manage houses of ill repute. Deadwood had many brothels, but none were more celebrated than those of the Badlands of Deadwood.

Prostitution was looked down on by socialites of the era, but stories of prostitution managed to find their way into the pages of newspapers regularly. The word "prostitute" was rarely used, so the papers opted for more imaginative names, such as soiled doves, sirens, loose characters and free and easy girls, among others. In the August 2, 1892 edition of the *Black Hills Daily Times*, we find this reference:

> *A colored Cyprian who, despite the ordinance preventing women of her class to loiter on the thoroughfares of the city, was arrested Sunday night by Marshal Garr in the act of soliciting male visitors on Main Street. The woman was given a severe lecture by his honor as this was her first offense, being a stranger in town and then turned loose.*

The newspapers were not alone in using monikers. Many of these women went by false names as well. Some of the more interesting names included Annie Fanny, Big Nose Betty, Cotton Tail, Fuzzy Girl, Nellie the Pig, Sizzlin' Kate and Venus Whore. One can only imagine how some of those names came to be. The names were well known and were used in the newspapers, and we find this entry in the July 30, 1892 printing of the *Black Hills Daily Times*:

> *Bismarck Annie, an old "76er" who has a record for having "got her man," and Battle Axe Leo, a woman equally as vicious and depraved, were arrested late Thursday night for drunken and disgraceful orgies, which they committed on the public thoroughfare…These two women with others whose depravity is even worse than theirs, occupy a building in the lower end of town where orgies are committed nightly that would put to blush Dante's Inferno.*

Many newspaper reports appear almost comical and certainly wouldn't have been too newsworthy by today's standards. Such is the case with this November 2, 1893 article from the *Black Hills Daily Times*:

> *Sunday night a certain prominent man of this city hid himself hence to the district known as the "bad lands,"…About 2 o'clock in the morning, the aforementioned prominent man's wife went to the place after him. She did not attempt to disguise herself nor the purpose of her visit, but after satisfying herself of her husband's whereabouts, marched up to the door and demanded admission. The woman opened the door in a few minutes but gave the man time to partially dress himself and make good his escape by a window. It is needless to say that he made lively tracks for home followed soon after by the irate wife. Names are withheld out of consideration for the wife.*

Many times, these soiled doves would not be looking for "business" but rather for a man they could "roll or touch." Men who came to the saloons

A True Wild West Ghost Town

Modern-day Main Street in Deadwood, looking south. This photo is taken from what was known as the Badlands. *Photo by Mark Shadley.*

became easy prey for these women after they had too much to drink. Men would often become sober only to find that money was missing or that they no longer had watches, rings, hats or various other personal possessions. It also appears that there may have been some competition between Deadwood and neighboring town Lead for business during the early years. This article from the *Evening Call* in Lead on October 21, 1894, took a passing prod at Deadwood:

> *Jack M., who is well known in this city, got touched for his money at Deadwood last night down at the Green Front...He is an old-timer in the country and everyone who knows him will be surprised at the easy manner in which he was fleeced. He lost $100 and up to date is still out the money. This should satisfy Jack with the sinful city and teach him to come to Lead where there is no danger.*

Finding any of the soiled doves of Deadwood's Badlands wasn't very difficult. The dance halls and saloons that had advertisements in the local newspapers also had unadvertised "entertainment" available. Many of these establishments offered rooms upstairs where these "ladies of the night"

plied their trade. The Badlands area was home to many of these buildings, especially as more permanent brick-and-mortar buildings were built on Main Street, below Wall Street. The north side of Main Street was nearly an entire block of buildings with "upstairs girls" at one point.

By the 1890s, many detractors were publicly voicing their opinion about these houses of ill will. Many residents had their names tarnished in public record due to being caught with such women. The Gem theater in Deadwood was targeted repeatedly due to being one of the most active. Common residents were not the only people fighting against the activities. Various visiting evangelists, local church groups and even the Salvation Army had campaigns with the goal of eliminating the places of ill repute. The residents of the Badlands in Deadwood were not so eager to see these locations shut down. In October 1892, a fire broke out at the local Baptist church, and it was partially destroyed. The floor had been sprinkled with coal oil, pointing to an act of arson. It's believed that the actual target was the Methodist church due to members of the congregation having been pushing a petition to get the Gem theater shut down.

In 1900, it appears that those "fighting the good fight" also resorted to fire as a weapon. The home of Grace Frawley, which was used as a boarding home for women of ill fame, had been set on fire by an arsonist. It was, in fact, the third or fourth fire in the "tenderloin" district within a very short time. The *Evening Call* of Lead noted that it was clear someone was "busily engaged in cleaning out the houses of 'ill-shape' in the down-gulch town."

In the early 1900s, the soiled doves had transitioned from dance halls and homes to the upstairs floors of some of the city's business buildings. The current Fairmont Hotel and Oyster Bay Bar on the corner of Wall Street and Main Street was the beginning of an entire block of "upstairs ladies" and their establishments. The Fairmont Hotel itself has a seedy past and will be discussed later.

Evidence and firsthand accounts point to a hidden entrance at the Fairmont Hotel building, as well as a way of being able to walk undetected up to the second floor, which housed the brothels. Not only could one get up to that second floor to the brothels, but there is also evidence that one could walk the length of the block inside the buildings on the second floor. This allowed "customers" to be able to enter the brothels undetected and walk through the various "female options" at their leisure.

The Bullock-Clark Building at 616 and 618 Main Street was built in 1894. The site originally was the Bella Union Theater, which was opened September 10, 1876. It was a well-publicized opening, with

A True Wild West Ghost Town

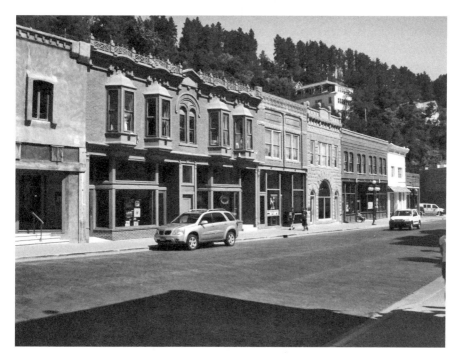

The Bullock-Clark Building, Main Street, Deadwood. Mannequins can be seen in the upstairs windows, denoting former brothels. *Photo by Mark Shadley.*

advertisements daily in the newspapers. The Bella Union Theater was considered to be a bright spot within the sordid places that surrounded it. Town meetings were commonly held at the Bella Union, and it is reportedly where the "miners jury" (group of assembled businessmen and miners from Deadwood) convened before finding Jack McCall innocent in the murder of Wild Bill Hickok. In November 1878, Tom Miller (proprietor of the Bella Union) went bankrupt. The theater later became a grocery store downstairs.

The building was destroyed in the devastating fire of 1879 that enveloped a large portion of the town. After the fire, Martha Bullock (wife of Sheriff Seth Bullock) and Horace Clark each built twenty-five-foot-wide buildings on the site. Another fire burned both buildings to the ground in 1894. The two agreed to build one large connected building shortly after the fire. The building later housed the Boston Restaurant on the first floor, while the second floor became the Deadwood Beer Hall. The second floor later became a barracks for the Salvation Army for a time before returning to a more disreputable existence as a brothel.

The next few buildings down the block also had respectable origins. The Horace Clark Building at 614 Main Street was built in 1900. It was known as the Club Restaurant and Palmer House Hotel, both of which were run by Sing You, one of many Chinese immigrants to early Deadwood. The Apex Building at 612 Main Street was erected in 1897 and housed the Government Assay Office for ten years. It quickly was used as a brothel upstairs and later became Pam's Purple Door (a brothel) until 1980, when all brothels in Deadwood were shut down by the federal government. A fire in 1982 destroyed the Apex Building, but it was later rebuilt as a nearly exact replica of the exterior of the original building.

The M.B. Wilson Building at 608–610 Main Street was built in 1902. It housed Henry Mallad's Pickwick Saloon, as well as "upstairs girls," from the day it opened. In the 1930s and 1940s, it became known as the Shasta Rooms. The L.M. Parker Building at 606 Main Street was erected in 1894 and is the final building of the block. The building later housed not only Pam's Purple Door, which extended into the second floor of the Horace Clark Building, but also Dixie's Green Door, the White Door (operated by Dixie Fletcher) and the Beige Door (run by Elsie Irwin).

Many of the surrounding areas had their brothels shut down by stringent laws and ordinances throughout the state. Deadwood seemed to be an exception, with the town refusing to give up the brothels. The truth is that the brothels in later years not only offered the expected "services" but also gave money back to the community in various ways. In 1959, a serious attempt to shut down the brothels was denied due to a negative public reaction. On May 21, 1980, state and federal agents finally raided the enduring brothels. In June, an injunction was issued that temporarily closed the houses of ill fame. Early October 1980 finally brought orders from the courts to permanently close the doors of the remaining brothels.

The buildings that housed these brothels on Main Street north of Wall Street still stand. Their past is not forgotten—most of them have various mannequins on the second floors of the buildings that are dressed in various pieces of lingerie. If you visit the Adams Museum in Deadwood, you can view many artifacts from the brothels, including an interesting flyer that advertises an auction of various items from the brothels after they were shut down in 1980. The authors have confirmed that these buildings are all still connected on the second floor. The buildings currently are not using the second floors, and therefore they are not open to the public.

A True Wild West Ghost Town

INVESTIGATION

Having a location that experienced such insidious activity over the course of more than one hundred years, it was no surprise to the members of Black Hills Paranormal Investigations (BHPI) that claims of paranormal events had been reported here. Employees claimed that the majority of the activity revolved around the second floor, which is now storage. When employees did venture upstairs, they reported feeling uneasy, as if they were being watched. Several employees reported seeing shadows and hearing footsteps in various areas. One employee reported standing next to a wall and feeling as if someone was pressing her legs and knees against the wall—she was unable to move them for a brief period of time. Other employees heard running footsteps that seemed to be coming from small children.

Taking all claims into account, BHPI set out on several investigations of the location. Multiple personal experiences came to light during these investigations. I walked into a room and heard a whisper that sounded like it had come from directly behind me. Upon turning, no one was behind me or within distance to hear a whisper.

Was this a working girl trying to entice a potential client? Both of the authors at different times during an investigation saw the same unexplained image. While standing in a room and looking out a doorway to the hall, Mark saw a shadow figure that appeared to peek around the doorway and then disappeared. Later in the night, I saw the same figure with the same movement, only on the opposite side of the doorway. The figure we both saw was short, perhaps the size of a child. Did we see the young child whom people claim to hear running in the upstairs?

The authors were both a part of another experience that cannot be explained. While Mark was near the end of a hallway, I stood at the entrance of the hallway as we conducted an EVP session. All of a sudden, a large dark mass appeared right in front of Mark. I noticed the same black mass. As soon as we noticed it, it disappeared. Neither of us could explain what we saw, but we agreed that something paranormal was there. Unfortunately, the experience was not captured on film. Was a former employee making her presence known, perhaps showing herself off to a potential customer?

Mark was taking a baseline reading with an electromagnetic field (EMF) detector when, while walking into a room, he caught a smell of perfume. Mark described the smell as floral and very feminine. Immediately after smelling what he thought was perfume, Mark heard footsteps down the

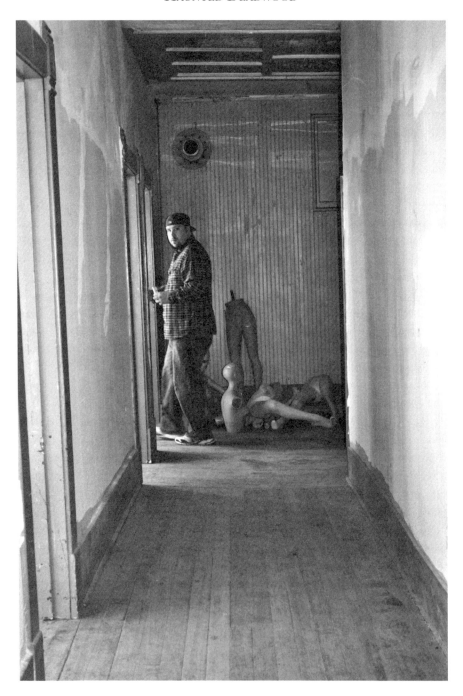

Author Josh Wennes in the former brothels on Main Street, Deadwood. The room Josh is entering is where he heard the whisper in his ear. Author Mark Shadley (taking the photo) is standing near where he smelled perfume and heard footsteps. It's also where the "Madam Gwendolyn" audio clip was captured. *Photo by Mark Shadley.*

A True Wild West Ghost Town

hallway. To Mark, they sounded like heavy boot footsteps, and they seemed like they were walking down the hallway away from him. He quickly gave chase, only to find that he was alone. He found that the entire group was on the other side of the building discussing the upcoming investigation strategy. He was informed that no one had ventured from the group and that no one was on the side of the building in which he had been. Were the footsteps a customer leaving after a visit to one of the ladies? Did the perfume come from a working girl preparing for another night of work?

After setting up our equipment one night, we left the premises and let the equipment run while we were gone to dinner. We had

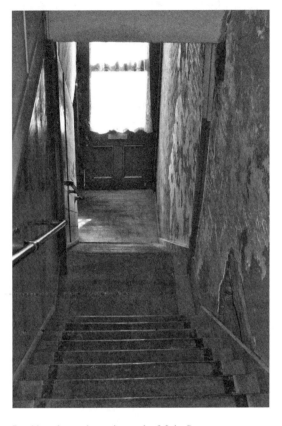

Looking down the stairs to the Main Street entrance of the former brothel of the Bullock-Clark Building. *Photo by Mark Shadley.*

audio recorders in the room where Mark smelled perfume. We also placed an audio recorder in the room adjacent to that room. Shortly after placing the recorders, both devices picked up the same ghostly voice. It definitely was a female voice, and it even had a singsong type of tone to it. It seemed to us that it said, "Madam Gwendolyn." Despite our research efforts, we could not locate any mention of a madam by the name Gwendolyn. Was this an employee looking for the madam in charge of the brothel?

At one investigation, we placed a video camera in the direction that Mark and I had seen the shadow figure. At one point, two investigators walked by the camera. The first investigator walked by and was visible through the entire doorway by which he walked. The second investigator walked past the doorway and was blocked out about halfway through the doorway by a

shadow that was not seen at the time. The shadow did not come from any flashlight as our lights were all off. We made numerous efforts to debunk the shadow, to no avail. The shadow, with the video paused, does appear to be shaped like a figure, possibly with a top hat. Did we witness a former client peering into a room?

A group of investigators caught another EVP while walking around inside the brothels. Despite not hearing it at the time of the recording, there is a voice that does not belong to any of the investigators. The voice is male and sounds like it says, "Last chance. Get your hurdy-gurdy." The interesting part of this audio clip is that it seems to fade away near the end, as if the energy used to produce the EVP was ending. After research, we discovered that the term "hurdy-gurdy" was used to describe a female entertainer in the late 1800s and early 1900s. Did the brothels have men shouting out to those on the street, trying to entice customers? Our research found no evidence of this, but the clip is compelling.

One of the stationary audio recorders during an investigation picked up another EVP that we couldn't explain. Amid the silence, a female voice comes through with a rather long rant. The voice is very audibly upset or annoyed. The voice is clear, but only a few words stand out enough to be understood. The clip starts off with the voice saying what sounds to us like "Anna May Clark." Despite our research, we could not find any reference to an Anna May Clark in any records. The other word that stands out very clearly in the middle of the clip is "Negro." Perhaps the most interesting feature of this clip is the fact that the voice has a thick southern accent. None of the investigators had a southern accent. Was the female in the clip a madam talking to her employees about a client? Perhaps it was a working girl complaining about a client.

One unexplained event that every member of the group experienced continues to baffle us to this day. The group had split into two smaller groups on opposite sides of the brothels. Both groups carried audio recorders as they walked around before the investigation had even started. Both groups, very clearly, heard a female voice call out "Woohoo." The voice was very melodic and seemed almost seductive. This disembodied voice was heard at the time of recording and was captured on both audio recorders. One recorder also picked up one group of investigators immediately after the voice talking about what they had just heard and mimicking the sound. Both groups quickly came to the conclusion that it must have been the other group of investigators. Each group was shocked when everyone reconvened only to find out that it was not the other group

A True Wild West Ghost Town

One of the "girl's rooms" before the brothels were shut down in 1980. *Courtesy Deadwood History, Adams Museum Collection, Deadwood, South Dakota.*

as they had thought originally. The voice seems like a soiled dove calling out to try and entice a potential client.

The former brothels in Deadwood saw their share of the villainous activity that seemed to permeate the town. Being active for such a long time, along with the emotional energy that was present every single day, it's no wonder that the location produced so much incredible evidence. As with Deadwood itself, the energy of the former brothels has refused to die. While one may not agree with the choice of profession, we all have the utmost respect for the former brothels and their inhabitants. The former brothels are a great snapshot of Deadwood throughout the years, demonstrating firsthand that the illegal activities that founded this town helped to ensure its success.

The "Badlands"

Think of any Wild West movie you may have seen, and images spring to mind. Saloons are filled with various early settlers that look like they've been digging into the ground for far too long looking for gold. There may be a woman on stage trying to earn some money by entertaining those men paying attention, and perhaps a working lady or two are looking down from upstairs, trying to entice the next customer. A fight may break out, the result of a poker player caught cheating or two men arguing over who "gets" the company of a working girl for the night. As clichéd as this scene may sound, it was indeed everyday life for those who lived on lower Main Street of Deadwood, known as the Badlands.

The Badlands section of Deadwood was located along Main Street, north from Wall Street. The Badlands name came from the immoral happenings and general debauchery of this section of early Deadwood. Within six months of the establishment of the illegal mining camp known as Deadwood, ten thousand people had rushed to the town in the hopes of striking it rich. Most were miners; however, others knew that these miners had needs. Soon, saloons and other businesses were established to take advantage of the booming population.

One of these establishments was a saloon known as Nutall & Mann's Saloon #10. This was the location of the assassination of Wild Bill Hickok. After Hickok's death, Nutall & Mann's continued to serve Deadwood until 1879, when the original building burned down. The location remained empty until 1898, when the I.H. Chase Building was erected. The Chase

A True Wild West Ghost Town

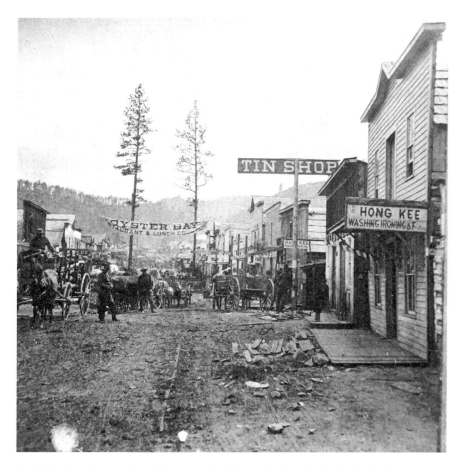

Early Deadwood photo from Chinatown, looking south through the Badlands. *Courtesy Deadwood History, Adams Museum Collection, Deadwood, South Dakota.*

Building housed a clothing store from 1898 until 1903, when Chase moved out. Frank X. Smith then moved into the building and opened a beer hall. Later, the Lucky Nugget Casino operated in the building and had opened an interpretive site that reenacted Wild Bill Hickok's final moment alive. Today you can see a sign that notes this building as the original location of Wild Bill's death.

Other buildings had reputations just as infamous, largely due to the person in charge. Ellis Albert "Al" Swearingen came to Deadwood in May 1876, shortly after its founding. Swearingen was one of the first people to come to Deadwood who wasn't a miner or prospector. He initiated the next wave of immigrants to the new town. He was lured to Deadwood in the hopes of making his riches not from the ground but rather the miners themselves.

After his arrival, Swearingen opened a small saloon known as the Cricket Saloon. Swearingen advertised entertainment for the miners after a long day's work. Prizefights were the main draw; miners were pitted against one another but were not awarded said prizes. This should have been a sign of things to come from Swearingen. Within a year, he had earned enough money to build a much larger building, one that Swearingen had dreamed of. Thus was the birth of the Gem Variety Theater.

On April 7, 1877, the Gem Variety Theater opened featuring prizefights and various stage shows, as well as prostitutes. Swearingen traveled to towns outside Deadwood to find employees. Complaints against Swearingen of abusing employees were common, including from his first wife. In December 1889, Swearingen skipped town for some time to avoid being arrested under a complaint put forth by his wife that he had choked her, repeatedly struck her and threatened her life. Swearingen was also very sensitive to employees who decided to try and terminate their employment with him. Swearingen would often threaten to blackmail (or outright blackmail) an employee. This would often prevent the employee from leaving or blacklist them from working.

Many of Swearingen's female employees were not those who freely chose such a career. In September 1894, one instance caused the *Black Hills Daily Times* to write this piece about the Gem:

> *Accompanied by the marshal, a* TIMES *reporter called upon three of the girls, temporarily sheltered at the Wentworth, yesterday afternoon. They are young—not out of their teens—were neatly dressed, and despite discolored and inflamed eyes the result of continuous weeping, presented an attractive appearance. They conversed freely, sorrowfully and at times with great indignation, saying in substance that they were engaged in honest employment at Chicago when they were allured by an advertisement in the News, for twelve girls to work in a hotel, application to be made to E.A. Swearingen, at 682 West Madison street, a saloon run by Wes Canagie, formerly of this city. Swearingen met them at a side door, and by representing himself as the proprietor of a large hotel, theatre and dancing pavilion, he effected an engagement with them, their work to consist of waiting on table and hotel work generally, for which he promised them $15 a week and board. It is needless to add that the hotel was pictured of elaborate proportions and in gorgeous colors. Mistrust occurred soon after starting, by reason of certain vile associates, deepened as the Hills drew near, and culminated in anguish as the hideous proportions and surrounding of the iniquitous Gem burst upon them in all its miserable reality.*

A True Wild West Ghost Town

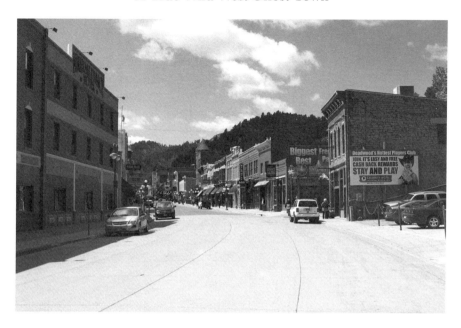

Modern Deadwood view looking south through what used to be the Badlands. *Photo by Mark Shadley.*

Despite his cruel tactics and cutthroat nature, Al Swearingen knew what he was doing. The Gem brought in an average of $5,000 each night, sometimes up to $10,000. By today's inflation standards, that's a nightly income of $140,000 to $248,000.

The massive fire in Deadwood on September 26, 1879, also brought about the destruction of the Gem. Swearingen was undeterred, and he rebuilt the Gem Variety Theater more luxurious than ever. The *Black Hills Daily Times* gave a preview of the new opening slated for December 31, 1879:

> [It] *is a much better building in every particular than the old one. The improvement is 30 x 100 feet on the ground. The interior is divided up in a convenient manner. The auditorium is 30 x 70 feet with a 24 foot ceiling; stage, 20 x 30 feet, with all the modern improvements for the shifting of scenery, and with dressing rooms underneath. The bar room is located in front. The second floor is occupied with boxes, nineteen in number, and so arranged as to give every one able to get into them a view of the stage. There will be a wine room and also a bar on this floor at the head of the boxes. On the whole it is just such a structure as a man who understands the variety business would build.*

Swearingen was just that man. He knew how to keep customers coming back. He made sure that the majority of the entertainment was lewd enough to attract the rough crowd that generally inhabited the area surrounding the Gem. To the surprise of most, Swearingen routinely brought in the highest caliber of performers to the Gem. In January 1892, local businessmen from Deadwood even petitioned Swearingen to allow the variety troupe performing at the Gem to play at the Deadwood Opera House so that "the up town people could step in."

The Gem had its variety of customers; a fair number of them were not interested in the stage shows. Some came to drink, some to dance and others for the "girls." Fights were commonplace among the rowdy crowd of men and coarse women. The "working girls" of the Gem were not immune to getting involved in these vicious encounters. A journalist wrote about one of these instances in 1884:

Gem Theater Slaughter

At a late hour last night, Gertie, a red headed siren, in a fit of jealousy, sailed into Dutch Ann with a knife, and carved her all about the face and head. It is thought one of Ann's eyes are gone, and there are desperate gashes in the back of her head and neck. The victim was carried off with blood, and the carver was escorted by the police to jail.

One of the trademarks for the establishment was the Gem band, which played nightly on the balcony yet offered a little extra in the way of advertising the business. Much to the chagrin of the upper-society members of Deadwood, it seems the musicians got off to a poor start. The *Black Hills Daily Times* on October 8, 1882, provided a glance of the public opinion of the band when it reported, "The Gem band has got one tune down to perfection, and plays it nightly with exquisite skill and most consummate grace and finish. Now if the boys would practice a new piece occasionally, the good people about the corner of Main and Lee streets would be everlastingly obliged to them."

It appears that no change was made, or if it was, it was short-lived, as evidenced by this January 27, 1887 edition of the *Black Hills Daily Times*:

The citizens of upper Main street desire the Times *to request the Gem theatre band which nightly fills the air with discordant sounds, to change its base, learn other tunes, use other instruments, or employ men who*

A True Wild West Ghost Town

have some little knowledge of music. It has become intolerable to refined ears, and if a change for the better is not soon made a vigilance committee will be inaugurated and Paul Rewman's telephone poles will bear fruit for the coroner.

The public in Deadwood was largely behind the Gem being rebuilt. There were some against the reopening, including several church groups that were not only outspoken but had also attempted to have the Gem shut down with multiple petitions. Some of Swearingen's biggest opposition came from Sheriff Seth Bullock. Reportedly, Wall Street was the proverbial "line in the sand" between Swearingen and Bullock and the parts of town they basically ran.

The Gem often found itself in the newspapers, and not always for advertising. In the December 19, 1878 copy of the *Black Hills Daily Times*, an author brought the Gem to the attention of the readers in an unusual way:

Cosy Temple of Amusement
Or
Den of Infamy
A boy stood back on the gallery floor,
At the Gem theater show,
And cast his earnest glances o'er
Bald-headed sin below
"I'm too far back," he sadly said,
Yet he dared not forward go,
For he saw his aged Father's head
First in the foremost row.

Gambling (often referred to as "Gold Belt Sports") quickly became one of the most common forms of entertainment in Deadwood. Miners and other citizens found this to be an enjoyable activity, a good way to spend time and forget the daily grind they all surely felt. Gambling, like prostitution, came incredibly early in Deadwood's existence. In addition to Wild Bill Hickok, other notable gamblers made their way to Deadwood. Some gained their reputation before their entrance into Deadwood, while others earned their fame in Deadwood itself.

One of the more famous figures in the city history was Eleanore Dumont, better known to those of the West as Madame Moustache. While young, she was said to have been very attractive despite a minor growth of hair on her upper

lip. By her arrival in Deadwood, Madame Moustache had put on considerable weight, and she had a clearly defined black moustache. She worked the Deadwood casinos during her time there and continued her renowned career as a card dealer. She often dealt faro and poker, and she was particularly fond of "vingt-et un," or twenty-one. She moved on from Deadwood, and upon her death, many newspapers of the West carried the story of her passing, including the September 10, 1879 edition of the *Black Hills Daily Times*:

> *A letter was received in this city, yesterday announcing the suicide of Madame Moustache, at Bodie, Cal. It seems that she struck an adverse run of luck out there and went broke, and rather than be a strapped faro dealer on these mundane shores, she took her chances in the great undiscovered country from whence no traveler ever returns. The madame is well known to Deadwood, having run a game here during the years 1877–78.*

As is common even in today's times, someone who came across substantial winnings quickly found that they had more friends and relatives than they ever realized. The *Black Hills Daily Times* on October 15, 1880, described this "frontier custom":

> *If there is any one thing funnier than another that happens nearly every day here in Deadwood, it is to see some one of the gang make a winning at faro and then attempt to get out of the room. From the moment he leaves the table with money in his hand, shoving it into his pockets, the rounders surround him and in all kinds of ways try to negotiate a loan. None of them want it longer than until morning, and none of them ever think of asking for more than five dollars, and from that down to the price of a meal. Men who can be seen on the streets every afternoon arrayed in matchless linen, with a profusion and such a make up generally as would lead a pilgrim to think they were bonanza kinds, can be seen at night trying to make the raise of a half a dollar in this way. If they are fortunate to make the raise, and they generally do, as the winner in all probability was a borrower the evening before, if hungry, the first thing is a square meal, and if there is anything left he chances it on the first losing card, to win at the next turn.*

Many lost everything, some of them not by the most honest means. While many became proficient at spotting different forms of cheaters, some were easy prey for others. On October 30, 1892, the *Black Hills Daily Times* ran a story about such an unlucky person:

A True Wild West Ghost Town

> *Andy Oleson, unaccustomed to the ways of a large city, fell into the hands of the Phillistines yesterday shortly after his arrival here (Deadwood). The cultures ran Andy against a loaded dice "crap game," the result being Oleson parted with his $150 as fast as he could place it on the table. Oleson, when his eyes became opened to a realization of the face that he had lost his money as surely as though he had dropped it piece by piece in the river, became frantic and implored the police to recover his wealth. They told him they would do all they could for him. Oleson is now asking for handouts at back doors, when he could just as well have been boarding at one of the Chinese restaurants.*

Gambling quickly and predictably found itself embraced by some of the local youth. Local police raided one such group of young gamblers in August 1890. A clip from the December 16, 1890 edition of the *Black Hills Daily Times* tells a story of a failed raid:

> *There is a gang of young hoodlums in this city ranging from about fourteen to twenty years of age that are engaged in carrying on gambling games in a room underneath Prof. Schofield's business house on Lee street. The game is run by a youngster not over sixteen years of age and it is said that some pretty good stakes have been placed on the game, which by the way, is a faro game, and is about as numerously patronized by the youngsters as any game in the town. The marshal got wind of the affair yesterday and started to pull the outfit but some one had given the hoodlums notice and nothing was found but table, benches, and chairs…There are some parents in this city who would be painfully shocked if they knew that their boys were not only playing at these games but were also engaged in conducting them, and if their boys persist in this work they will all be exposed sooner or later as the marshal means business in hunting down any resort they may choose for carrying on this unlawful business.*

In spite of the numerous periodic raids that seemed more of a nuisance to the sites of illegal gambling, these institutions of Deadwood continued on. A major crackdown took place in 1947 but was unsuccessful, and gambling lived on for many years. The buildings stopped being home to gambling but still occasionally hosted wagering whenever the residents felt the familiar itch. In 1989, South Dakota residents voted to approve limited gambling in Deadwood. The difference this time was that much of the tax money that was collected went toward historic preservation. One of the "unsavory"

Haunted Deadwood

events that helped start the once illegal mining camp of Deadwood has become one of its leading attractions.

Opium made its way into the Black Hills much the same way it did to the United States as a whole, from China. While opium showed promising medicinal properties, many users, adult and children, quickly became addicted. Opium produces a very pleasurable feeling of euphoria. It also proved to be cheaper than alcohol, making it much more accessible to everyone.

The use of opium came to the Black Hills and Deadwood with the immigration of a sizable Chinese population. Early settlers of Deadwood looked on the smoking of opium by the Chinese with curiosity and looked to local media to help educate them. On August 1, 1877, a reporter from the *Black Hills Daily Times* documented a visit to an office of Dr. Long Kee in Deadwood's Chinatown (down Main Street, beyond the Badlands). Dr. Kee provided an insight into Opium, as well as a tour of his building. A very detailed look was given on July 16, 1878, by the grand jury of Lawrence County when an official report was produced. An accompanying reporter described the activities in the *Black Hills Daily Times*:

> *We met at the Bella Union at 1 o'clock p.m. conceiving this to be the most propitious hour for our investigations. From thence wending our way down Main street, we came to a two story dive kept by Lee & Ton. There we found a few Mongolians listlessly reclining on their pallets, smoking. It was obvious that this house had been notified of our intentions, as it was practically deserted. We were more successful in our next descent into an underground dive. Here we found a young girl on the pallet with a young man reclining on either side. The cot is a rude structure made of boards covered with an oil cloth or in many instances a grey blanket, at the head, a board six inches wide and elevated about four inches, provided with pillows to rest the head upon, with a lighted lamp in the center of the cot, a card of opium and a pipe from which each take their smoke alternately. A wire is used, on the point of which is rolled a quantity of the opiate sufficient to make or fill the pipe. This is cooked over the lamp and then ingeniously and dexterously manipulated preparatory to the smoking. The pipe has a long stem with an oval or convex head, and a small tube or hole in the center around which is collected the opium. A vent is made by means of the wire passed through the opium into the tube. The pipe is then placed over the lamp. The smoker sucks or inhales all that can be taken in at one breath and then exhales the smoke or fumes from the*

> *nose or mouth as the smoker prefers. Two whiffs were all that the pipe contained, which we saw. It is then refilled or refitted, each operation requires about five minutes to prepare it and but a few seconds to smoke it. The victims are reduced to a semi-unconscious state when all is placid, calm, serene, no hilarity or mirth is observable, and if there is any enjoyment in its effect it must be in the mind or imagination of the smoker. It is apparently an enticing poison which takes a slow but sure hold on its victim. We visited other dens and found (very unexpectedly) many whom we meet in the better circles of society. Alas! that human nature should be so frail.*
>
> *Each and every opium house visited upon that occasion has been indicted as a public nuisance, the proprietors arrested but have been admitted to bail and are now plying their nefarious vocations. A stringent Territorial law is what is wanted and our representatives should be instructed to that effect.*

Opium houses were often looked down on because of the distasteful people commonly associated with them. There are reports of other reasons for the displeasure surrounding these opium dens. In August 1879, the local newspaper forwarded a plea from a Deadwood resident that pointed out an interesting dynamic about the opium dens:

> *A lodger on upper Main street adjoining Miss Scar Face Charley's quarters, informs us that her rooms have been turned into an opium den, but whether for the public accommodation of the slaves to the habit, or just for a quiet private resort of her personal friends and victims of the disgusting practice, we are unable to say. According to our informant the sickening fumes of the opium from her place freights the air of the whole neighborhood with that peculiar nauseating stink of that soul-destroying narcotic. If there is a law for the suppression of this evil, why is it not enforced?*

Periodic raids of these opium dens occurred but never seemed to completely stem the businesses. A reporter from a local newspaper questioned an officer about the existence of the opium dens. He is reported to have replied, "Certainly, but what is the use of breaking them up, there is never anything done with them after we arrest them." One must wonder if the previous article citing members of upper society being found in opium dens sheds light on why these dens kept returning. Despite the apparent lack of punishment, opium's hold on the citizens of Deadwood began to weaken through the early 1900s before eventually disappearing.

Haunted Deadwood

Interpretive site from the former Lucky Nugget Casino depicting Wild Bill's final moments. The site is as close to Wild Bill Hickok's murder location as can be determined. *Photo by Mark Shadley.*

We, along with the Black Hills Paranormal Investigations team, had the opportunity to investigate the closest location to Wild Bill Hickok's untimely assassination. The area at the time had been converted into a bar with an interpretive site downstairs depicting the death of Wild Bill. There were claims of items moving at the bar, including glasses being pushed off the bar by unseen forces. Witnesses had heard on the steps of the interpretive site the sound of light, running footsteps that seemed like they came from a child. One person even reported seeing an apparition of a Chinese man walking in the hallway near the interpretive site. BHPI members did not hear any claims of activity that pointed to Wild Bill himself. We also did not capture any evidence that indicated Wild Bill as a presence at the location.

What we did capture was a single photograph that may show the spirit of the young child heard on the steps. The picture was taken in complete darkness, with only the camera's flash illuminating the area. On the stairs, a figure can be seen that was not present while the picture was taken. While

there is a glare that appears to be right where the figure's head and face would be, other details can be seen. The figure does not match any of our investigators. Was this image that of a child who used to hang around the Badlands? While we cannot claim this photo to be absolute proof of a child inhabiting the area, we can say with certainty that the history and events that took place throughout the years left an indelible impression on this section of Deadwood.

The Fairmont Hotel

The building that is now home to the Fairmont Hotel and Oyster Bay Bar has a long past that has experienced nearly everything that Deadwood has offered in its history.

In 1903, the property went by the name the European Hotel. It also housed the Mansion Saloon inside. The building later became known as the Carr and Berry Building after the co-owners. The property housed not only a saloon and hotel but also a barbershop in the basement, as well as a place to gamble. It also became a "speakeasy" during prohibition with an interesting way of serving alcohol. Different types of alcohol were placed in jugs that were hidden beneath the basement floor. Straws were inserted that stuck up through the floor, allowing easy access for patrons.

The building experienced its share of tragedy as well. On August 28, 1907, a woman named Maggie Broadwater leapt from a third-story window to the street below. Despite the tragedy of Maggie's death, there is more to the beginning of this story. Maggie was known in the Badlands as Marguerite. She had recently returned to Deadwood from Thermopolis, Wyoming, where she was visiting a man she had been seeing. There is no information that explains what happened to Maggie during her trip. When she returned, it was obvious that something had happened. She was in some state of emotional distress, appearing extremely flustered. She quickly took to one of Deadwood's biggest vices, alcohol. The *Pioneer-Times* described her downfall very poignantly: "[Broadwater] attempted to bury her sorrows in the flowing bowl. The bowls became so frequent

A True Wild West Ghost Town

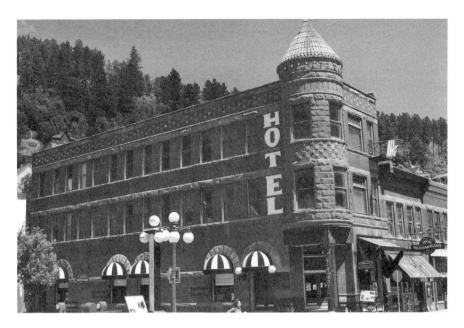

Side view of Fairmont Hotel and Oyster Bay Bar. Maggie Broadwater jumped from the third floor, fourth window from left, in 1907. *Photo by Mark Shadley.*

that she had been more or less intoxicated and it was while half crazed with drink she attempted self destruction."

This is when she committed her act of jumping from the building that is now the Fairmont Hotel. There was an inquest into what happened, and it produced statements about the event. Mrs. Rita Hall, a housewife living in Deadwood, witnessed the event and provided the following account:

> *About 12:30 pm on August 28, 1907, I was upstairs in my house and upon looking down and towards the Carr and Berry Building, I saw a woman put her foot up on the window on the 3^{rd} story and then sit on the window. She then got up on her hands and knees, turned around and pushed herself off. She turned over in [and] her fall struck the ground in the alley.*

One of the co-owners, P.N. Carr, also provided testimony of what he heard had happened, as well as a chilling message from Maggie Broadwater herself: "[O]ne of the girls had fallen…on the way to the hospital she said she wanted to die."

Maggie was pulled out of the mud hole in Wall Street and taken inside the hotel before being taken to the hospital. It was reported by the *Pioneer-*

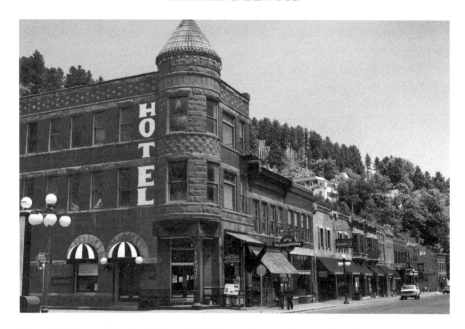

View of Fairmont Hotel and down Main Street. One could enter the Fairmont Hotel's basement to appear to go to the barbershop and then walk up to the second floor and traverse the entire block and their brothels.

Times that she would survive without a doubt. Maggie would prove them wrong, succumbing on August 30, 1907, at 5:30 p.m. A verdict of jury was completed on the cause of her death on October 1, 1907: "Hemorrhage and shock produced by a tear of the bladder and also by fractures of the jaw and left arm. These being caused by the deceased throwing herself from the window of the third story of the Carr and Berry Building. In the opinion of the jury with suicidal intent."

Maggie was buried at Mount Moriah Cemetery, but she was not the first Broadwater to have been buried at the cemetery overlooking Deadwood. Nearly a year to the day that Maggie jumped to her death, a baby named C.C Broadwater died, was buried at Mount Moriah and was later shipped to another location. What cannot be documented is if the baby was any relation to Maggie. There are many questions that this raises. Was the anniversary of Maggie's baby's death the cause of her ultimate demise? Unfortunately, it's not something we can verify.

The Fairmont Hotel saw its share of gambling over the years, including under the ownership of Bernie Lesprince. Bernie was an avid gambler himself and made quite a small fortune hosting a small casino at the Fairmont Hotel. Due to his love of gambling, Bernie carried $4,000 to

A True Wild West Ghost Town

$5,000 with him at all times, in case a game that he liked showed up. This may have contributed to his ultimate demise. Bernie was found dead, with no cash on his person. Did a thief murder him because of his reputation for carrying large amounts of money? Bernie had a craps table at the Fairmont, and that craps table was found by the current owners when they purchased the building in 1990.

Another tragic event surrounded the Fairmont Hotel. The rooms upstairs were used as a brothel. One of the "working girls" occupied the first room beyond the stairs on the second floor. A man who went by the name Vinegar Rowan was a frequent visitor to this room and became infatuated with the woman who called it home. Being a "working girl," it was inevitable that she began seeing other men for business. Vinegar Rowan eventually found out and became infuriated. He rushed to the room and burst in through the door to find the woman with another man. He produced his pistol and shot the man. As Vinegar shoved his pistol into his belt, the gun went off, hitting his thigh. Rowan rushed down the stairs and out into the street. The wounds proved fatal for both men.

We had the opportunity to discuss the building, its history and the reports of paranormal events with current owner Ron Russo, who purchased the Fairmont Hotel and Oyster Bay Bar in 1990. Even before purchasing the Fairmont, Ron said that he had a bit of an ominous warning. "Some of the previous owners made it pretty obvious that I wouldn't be comfortable here. They said they would never tell me what they'd seen over the years." Ron reported.

After the sale, the previous owners stayed at the Fairmont for a time. The owners' mother stayed with them and would frequently walk around the building with her walker. Ron reported that at times she would appear to talk to herself and say, "He wasn't there," or, "She wasn't there." Ron never questioned why she did this, but he did say that it was creepy and that no explanation was ever given. Was she trying to convince herself she had not seen something or someone?

Bartenders at the Oyster Bay Bar frequently report seeing a man wearing a black hat and long black coat. They report seeing the man walk out of where the women's bathroom is, walk across the room and then disappear. The face of the man is never seen, and bartenders who have called out to the man get no response. The man walks as if with purpose, never looking around or straying from his path. Is this a former client of the building or perhaps even a former owner?

Ron reported commonly having a creepy feeling when on the staircase. Granted, the stairs are old and creaky, but Russo said that it was beyond that.

Stairs of the Fairmont Hotel that Vinegar Rowan used to flee the hotel. These are the same stairs where Ron Russo has felt someone rush by him on multiple occasions.

He has also felt like someone has rushed by him while on the stairs. Ron added that it always feels like someone is rushing *down* the stairs. It never makes any impact on Ron—it's just a rush of air as if someone has run by him. Has Ron been experiencing Vinegar Rowan running down the stairs after shooting a man and mortally wounding himself?

Ron also said that he has heard numerous reports of people seeing an old woman with gray hair on the third floor looking down the stairwell. This is not a phenomenon that Ron has personally experienced, but he knows that there was no one in the building like that when it was reported.

Many who stay in the room where Vinegar Rowan shot a man report unusual activity. An employee of Ron's stayed in the room for three years and talked about being patted on the backside several times when no one else was around. Was this a former "working girl" trying to get a potential client? Three different people staying in the same room reported having their arm moved while they were sleeping. All three reported the same experience. The three people did not know one another, and none of them knew that there had been any other reports.

Ron mentioned that he frequently has people come in and ask to go investigate the hotel. While many walk in very confident, Ron said that

A True Wild West Ghost Town

many leave in quite a hurry: "We had a couple of people come in, one investigator and one lady who said she was a psychic or medium. They went upstairs and came down in quite a rush after a short time. The investigator came back into the building and told me that they experienced a lot and that the lady was refusing to come back into the building. They left, and I never saw them again."

Ron reported that two different paranormal investigative groups had come in with a lot of different equipment. The groups came back and reported pretty similar experiences while upstairs:

> *The first group was English, and they said on the second floor they saw a ten-year-old boy. They said he was in period dress, and he definitely had white shoes on. I had another group come in maybe ten or twelve years after that. They came down and said they had seen a ten-year-old girl in period dress with white shoes on. Now I believe that they both saw the same apparition, but I think it was the girl, and I'll tell you why. It was very common for little girls of the time to wear white shoes, but not boys. Boys were given black shoes because they would play and get dirty.*

Perhaps the most interesting story that we heard from Ron was something he had experienced himself. Ron was staying at the Fairmont Hotel, sleeping on the third floor, under the fourth window from the end, where Maggie Broadwater jumped to her death:

> *I was in a very sound sleep and was startled out of it all of sudden and found my eyes fixed on the clock. It was exactly 3:33 a.m., and for some reason I wasn't able to move my head. My entire body seemed stuck except my eyes—I could move my eyes to somewhat look around. When I glanced at the foot of the bed, there was a woman standing there. I was alone in the building so it wasn't anyone that I knew of, and I know it wasn't a dream. The woman had red hair, and she was wearing a green dress. I know that I saw Maggie Broadwater. I don't know if she ever owned a green dress or if she had red hair, but it was Maggie Broadwater.*

The Fairmont Hotel has quite the history and definitely is part of Deadwood lore. If you find yourself in Deadwood, be sure to stop into the Oyster Bay Bar at the Fairmont Hotel and talk to Ron Russo. You won't be disappointed.

The Bullock Hotel

Seth Bullock is a true westerner, the finest type of frontiersman.
—*Theodore Roosevelt*

The Canadian-born Seth Bullock was a successful politician, businessman and lawman in Montana long before he came to make his mark on Deadwood. At age twenty-one, he served in the Montana Territorial Senate, where he was instrumental in introducing legislation urging Congress to establish Yellowstone as a national park. At the age of twenty-four, he served as sheriff for Lewis and Clark County. Bullock partnered with another successful Montanan, Sol Star, in the hardware business, and Star also went on to be a successful entrepreneur in Deadwood in his own right. Like Bullock, Star was involved in Montana political affairs, serving as territorial auditor and personal secretary to the governor of Montana.

When Seth Bullock and Sol Star heard about the gold discoveries in the Black Hills, they realized the potential, loaded several wagons full of supplies and headed to Deadwood. What they understood was the age-old theory of supply and demand. Many of those who came into Deadwood could not just go to a store to buy what they needed. There were no stores. If the miners had not packed it into this wild land, they would have to go without or travel more than 150 miles to obtain the supplies they needed. Bullock and Star were prepared to provide a much-needed service as they packed Dutch ovens, fry pans, dynamite, axes, rope, picks and shovels—everything that would be in high demand by the

miners flooding Deadwood Gulch. They even brought in the first chamber pots into Deadwood Gulch and promptly auctioned off their supply the very first day. They arrived in Deadwood on August 1, 1876, the day before Wild Bill Hickok was shot and killed, and opened the Office of Star and Bullock, Auctioneers and Commission Merchants on the corner of Wall and Main Streets where the present-day Bullock Hotel is located.

In March 1877, South Dakota territorial governor John L. Pennington appointed Bullock Lawrence County's first sheriff. He never once had to use his gun in the performance of his duties, which was something rare in the early days of Deadwood and western law enforcement. In *Pioneer Days in the Black Hills*, John S. McClintock wrote about Bullock's qualifications to serve as sheriff:

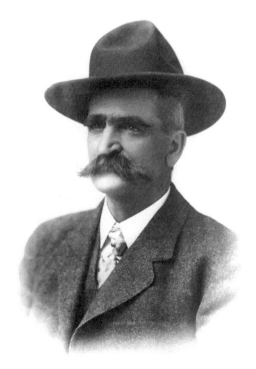

Seth Bullock in later years. Several people have claimed to see Seth's ghostly spirit walking the hallways of his hotel. *Courtesy Deadwood History, Adams Museum Collection, Deadwood, South Dakota.*

Sol Star, Seth Bullock's hardware and business partner. Star went on to also be a prominent citizen of Deadwood. *Courtesy Deadwood History, Adams Museum Collection, Deadwood, South Dakota.*

> *Seth Bullock proved himself to be an officer of good judgment, endowed with the rare faculty of keeping his own counsel. Being also a good judge of human nature he seems to have known just how far it was advisable to go, and when and where to halt in the performance of his duties. He was a man of good moral character, in accordance with which his deputies evidently were selected. Truly may it be said that during the brief term of his official service the turbulent, lawless and grossly immoral conditions which were prevailing throughout the county, and more especially in Deadwood where the semblance of a city government existed, were greatly ameliorated.*

Bullock had a certain intensity about him, and it was said that his steely gaze was enough to defuse the most intense confrontations. He was also smart and fair when dealing with sticky situations, especially when it came to a miners' strike. Miners working a claim for a seedy character had not been paid their wages, so they decided that they would stock the mine with supplies and their bedding and barricade themselves in the mine until paid. As this was an interruption of operations for a productive mine, the military was called in to get the miners out; however, no amount of threats could dislodge the determined miners. Judge Granville Bennett ordered Sheriff Bullock to end the strike with one caveat: there was to be no bloodshed. Bullock noticed that the mine had an airshaft and devised a plan to smoke the miners out. With a devilish smile, he dropped a foul-smelling substance down the airshaft that eventually overcame the striking miners so much that they had no choice but to exit the mine for fresh air, which effectively ended the strike without injury. Estelline Bennett mentioned that her father, Judge Bennett, got great enjoyment in telling this story of Bullock's inventiveness in ending the strike without one injury.

A Historic Friendship

In 1884, while Bullock was out riding his ranch property near Belle Fourche, he happened across a camp occupied by three rough-looking characters. As he carefully questioned them about their presence, he learned two of the men were lawmen transporting a prisoner. When introductions went around camp, one of the men introduced himself as Theodore Roosevelt, the future

president of the United States. This chance meeting would be the beginning of a lifelong friendship between Roosevelt and Bullock.

With the outbreak of the Spanish-American War in 1898, Bullock enlisted in Roosevelt's famous Rough Riders outfit as a captain in A Troop, serving in "Grigsby's Cowboys" regiment. After the war, Bullock was appointed to the position of supervisor of the Black Hills National Forest at the suggestion of Vice President Roosevelt. When Roosevelt was elected president, Bullock was invited to attend the 1905 presidential inauguration. Being friends with a sitting president apparently had its benefits as in that same year, Roosevelt appointed Bullock U.S. marshal for South Dakota.

When Bullock's longtime friend Teddy died in 1919, Bullock, himself gravely ill, enlisted the aid of the Society of Black Hills Pioneers to erect a monument to his friend's memory on top of Sheep Mountain, later renamed Mount Roosevelt. The monument, dedicated on July 4, 1919, was the first monument in the country dedicated to the late president. Not long after Roosevelt's death, Seth Bullock passed away on September 23, 1919, at the age of seventy in his modest Ingleside home located at 28 Van Buren, not in room 211 of the Bullock Hotel as is often reported. Before Bullock died, he secured a plot above Mount Moriah Cemetery where his grave site could overlook Roosevelt's monument. Today, ninety-three years later, that view is blocked by a stand of ponderosa pine.

When Seth Bullock died, a little slice of the American West died with him. He was the embodiment of the true spirit of Deadwood and of the era—not what we see depicted today in Hollywood westerns. Bullock was the genuine article; he was a flesh-and-blood man interested only in making a living and a better place to live for his family and community.

The Bullock Hotel

The current site of the Bullock Hotel, located on the corner of Wall and Main Streets, is built on the original foundations of Sol Star and Seth Bullock's hardware store and warehouse, established in 1876. After the fire of 1894 destroyed the hardware store, leaving only the brick warehouse known as a fireproof, Seth Bullock and Sol Star decided to build a luxury hotel on the property incorporating the burned foundations and warehouse. When finished, the hotel boasted sixty-three "luxury sleeping

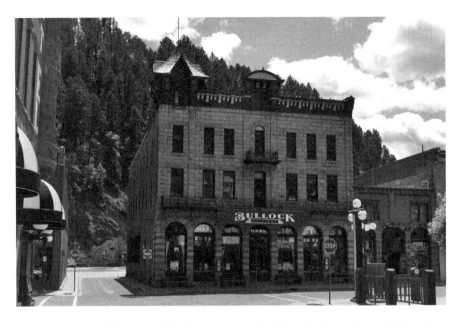

The Bullock Hotel. Mount Moriah Cemetery is on the hilltop in the background. *Photo by Mark Shadley.*

rooms," a restaurant that could seat one hundred people, an ornately decorated lobby with brass chandeliers and a second-floor library and parlor, with a bathroom on each floor. After an extensive year-and-a-half renovation in the early 1990s, the hotel's original sixty-three rooms were converted into twenty-eight larger rooms.

Before the hotel was built, the cellar of the hardware store housed a blacksmith shop whose smithies worked at night repairing mining equipment and wagons and shoeing horses. One story claims that during the smallpox outbreak in 1876, the basement of Star and Bullock's hardware store was used as a makeshift hospital to treat the afflicted. There are no records to establish the veracity of these claims, but there is a popular story among the employees of the hotel that a prostitute and her daughter died of smallpox in the basement and that the little girl, Sarah, still haunts the hotel. Sarah's ghost may be the culprit behind reports of a little child playing in the hotel hallways.

Some say that only a few rooms are haunted, but hotel staff will tell you that there is not a room in the hotel in which paranormal activity has not occurred. Guests and employees alike have also reported seeing the ghost of Seth Bullock walking the hallways in the hotel.

A True Wild West Ghost Town

Ghost Stories

Although many locations in Deadwood can lay claim to haunting activity, the Bullock Hotel can arguably boast the most thoroughly documented claims of hauntings over the years. The Bullock staff has encouraged guests and employees alike to document their paranormal experiences and collect them into a notebook that is on display in the hotel lobby. There are literally hundreds of guests who have stayed in the hotel and reported seeing full-bodied apparitions of Seth Bullock. Others have reported being locked out of their rooms or feelings of being touched, while others report that the room's showers turned on and off on their own, as well as loose change carelessly thrown on a dresser being found neatly stacked by unseen hands.

There is no doubt that some guests have misinterpreted certain experiences as ghostly encounters, but one cannot overlook the fact there is a long, consistent and compelling history of hauntings taking place in the Bullock Hotel. With the popularity of ghost hunting shows on television, people have taken a renewed interest and really want to experience the paranormal. The staff at the Bullock Hotel would have you believe that there is no better location to visit in Deadwood than their hotel to fulfill that wish, and that is what makes the Bullock Hotel such a big draw and what makes their ghost tour a popular attraction.

The employees of the Bullock perhaps have some of the most compelling experiences to tell. One long-term employee of the hotel told the story of a little boy who became locked out of his room and was helped by a nice older man who was later identified as Seth Bullock's ghost:

> *I maybe worked here about two years when I hear a little boy telling his dad that the man in the picture was the one who helped him get back into the room when he got locked out. I looked at the picture on the wall and saw it was Seth Bullock's picture. That shocked me. I talked to the people and they had stayed at the hotel that night, and went downstairs, leaving their son in the room. I guess like all little boys he got bored and left the room to roam the hotel. I guess he didn't realize the door locks when it closes, and he didn't have a key. He was wandering the hallways, when he says an older tall man with a big mustache told him he would help him find his room. I guess the man who walked him to his room was Seth. He saw Seth's picture the next day and said he was the man who helped him get back in his room. Before this happened, I really didn't have an opinion one way or the other about the stories I heard about the hotel. I think a lot of*

> *the stories people tell might be trying to make something more of it than it really is. But I can tell you this incident with the little boy makes me think something is going on.*

This employee also told a story about a guest who was rudely awakened by a loud, dirty, cigar-smoking cowboy walking the hallways:

> *Sometime in the mid-1990s I remember the front desk getting a complaint from a lady staying in the hotel. It was about three in the morning when this lady calls the desk and tells the clerk she is "appalled" that the hotel would allow a dirty cowboy to walk down the hallways smoking a cigar. The desk clerk told the lady that we had no cowboys in the hotel, and the clerk asks the lady what the cowboy looks like? The lady says she only got a look at him walking down the hallway from her and saw his pants were tucked into his boots, he was wearing a big brimmed hat and the smoke from the cigar was swirling around his head. I guess she had seen old Seth walking the hallways.*

One experience convinced this employee that there really might be something going on in the hotel:

> *I was working in the bar one night next door when the hotel ran the bar there. I was standing near the bar when a whiskey bottle came flying off the top shelf and landed several feet away from the bar. It really scared me because the bottle hit really hard. At first, I was trying to think about where the bottle was on the shelf and knew there was no way it could have come off that shelf like that.*
>
> *A little while later, while I was working in the bar at the hotel, another whiskey bottle came flying off the top shelf again. It was the same brand of whiskey that flew off the shelf in the other bar so I stopped putting that whiskey on the top shelf and never had a problem again.*
>
> *I don't know, I really didn't think there was anything going on. I thought people were just making these ghost stories up, but now I think there might be something to the stories.*

Molly VanNorman came to work for the Bullock Hotel in 2010. She admittedly knew very little about the history of Deadwood and even less about the Bullock Hotel. However, after experiencing strange activity over the years, VanNorman has become a self-styled historian of the Bullock Hotel and guides the weekend haunted tours of the hotel.

A True Wild West Ghost Town

VanNorman described her very first day of work at the hotel, when she received an unexpected introduction to the mischievous spirits of the hotel:

> *I started working here at the Bullock in May 2010. I didn't know anything about the Bullock and knew a little bit about Deadwood. I really didn't know about the history at all. On my first day, they had this photograph of Seth in the manager's office that used to hang above the mantel of the fireplace in the restaurant. I asked what they were going to do with the photograph, and they told me they were looking for a place to hang it. Since I am a little bit of a smart aleck, I suggested they glue the photo to the ceiling of the money cage so that the first sheriff of Deadwood can watch them as they count the money. Not three or four seconds after I made this joke, a box fan that was sitting in the back corner of the room, slammed against the wall and fell over. So apparently Seth was not a fan of my humor.*

Only a few days later, VanNorman had another ghostly encounter:

> *I was working the front desk during my first week. There was a lady looking at the book of ghost stories of firsthand experiences located near the front desk. I was working at the computer, and I looked up and she's over at the book, and I looked over at the phone behind her and there was a dark figure, a dark black silhouette. You could see through it is the easiest way to describe it, of a cowboy leaning up against the doorjamb. About six foot, six foot one, and you could make a few features out but not a whole lot. I said, "Turn around," and scared the lady on accident, I took my eyes off of it and apologized to her but wanted to see if she saw it, and she did not. When I looked back, it was gone.*

VanNorman also described an experience involving guests of the hotel and a door that would not open:

> *My biggest experience happened the first year I worked here. A family of four checked into the hotel, and since they were staying in room 211, I asked them if they knew they were staying in one of the most active rooms in the building. The people thought I was joking and continued to check in. They were rock climbers that just came in from Devils Tower and had all of their ropes and equipment. After checking in, they took all of their equipment up to the room along with their baggage.*

About four hours later, the entire family shows up at the front desk, and the father asks, "Have you been in our room, and are you playing a joke on us?" I told him I had not. The father held up the key to the room and said, "We can't get in the room." This is not unusual because the doors are old and the latches will get caught. I went upstairs with them to help them and found the door to their room was unlocked, and the door was open about half an inch, but the swing bolt that is a brass latch had gotten latched from the inside. I tried to get the latch unlocked, but could not get it unlocked. I told the family I had to go downstairs to call maintenance so they can come up and get the door open. As I turned to head downstairs, there was a lady standing there watching. She was waiting to get into the room next door in 213. I asked if I could go through her room to get into these people's room and unlock it since I noticed the connecting door in 211 was open. She said she had no problem, and I went through her room, unlocked the connecting door into the room. I looked at the door and saw a rock climbing rope was tied around the swing bolt. When the family came into the room and saw the rope tied around the swing bolt they were pretty scared. Their youngest son would not stay in the room after that.

VanNorman said that some members of the housekeeping staff have quit because of strange happenings in the hotel, and there are a few who will not enter certain rooms. She explained that there have been reports by guests and hotel staff of the showers in the rooms turning on and off. Some housekeepers have reported that the towels they used to prop open a room's door while in the room cleaning have been seen flitting across the floor on their own. There are also reports by guests who claim to have heard classical music wafting through their rooms; however, when they investigate, they can't find a source. Several people have reported instances of being touched by unseen hands, and others report that small items such as keys and cellphones tend to go missing and are later found in unusual locations in their rooms. VanNorman said some people believe that only a few rooms in the hotel are haunted; however, she confides that she believes pretty much every room in the hotel has had some sort of haunting activity take place.

VanNorman explained that one of the reasons she believes the Bullock has such a high rate of hauntings is because the basement was one of the locations used in Deadwood as a hospital to treat victims of a smallpox outbreak in 1878. During this outbreak, numerous people lost their lives. VanNorman admits that there is no record that definitively documents how many deaths, if any, took place in the hotel's basement or if the basement

A True Wild West Ghost Town

was used at all as a makeshift hospital as all records were destroyed in the great fire of 1879.

Many employees and guests have reported strange activity in the basement, including hearing their names being whispered and experiencing the chairs in the bar moving on their own. Some guests have claimed that the ghostly likeness of Seth Bullock himself has appeared in their photographs of the basement, especially around the bar. Others claim that they have sensed and seen a little girl in the basement.

Since the hotel is a year-round operation, it is very difficult to adequately conduct a proper paranormal investigation in a controlled environment and without outside contamination. However, it seems apparent to those who have experienced something that one simply needs to walk the hallways or stay in one of the active rooms to experience haunting activity. Our impromptu investigation was simply that: walking the hallways and standing around in a few empty rooms, snapping photographs and carrying a digital recorder. Even though our experiences were not eventful, we did get an opportunity to investigate a mirror that is said to channel Seth's spirit.

The mirror in question sits on the second floor at the top of the grand staircase. When photographs of the mirror are taken, the pictures allegedly capture what appear to be the letters "A," "H" and "T" (or a cross). The story told is the "A" is Seth's spirit communicating that life after death is absolute. The "H" is said to stand for "hat," and the "T" (or cross) represents a religious connotation. Our investigation of the mirror has shown that there is a much more reasonable explanation for these artifacts showing up in the photographs. Upon inspection of the mirror, the authors noted that the beveled edges of the mirror reflect the light waves of a camera's flash, projecting that reflection onto the opposite wall. Depending on the photographer's orientation to the mirror, the camera captures this reflection in the form of an "A," "H" or "T."

Although some of the claims of haunting activity taking place within the hotel may have a reasonable explanation, one cannot simply ignore the hundreds of compelling experiences encountered by guests and employees alike that have been documented over the years. There are too many people who have experienced the same type of activity at different times and without knowledge of other experiences. This kismet, if you will, must lead one to at least entertain the notion that something paranormal is taking place in the hotel. Seth Bullock was a significant and important figure in the history of Deadwood and the Black Hills. Based on the many stories of his character, it may not be too far flung to believe that he still hangs around to keep an

The "haunted" mirror of the Bullock Hotel depicting the alleged "A," "H" and "T." The authors were able to debunk this phenomenon as reflected light produced by the flash of the camera. *Photo by Mark Shadley.*

eye on his holdings, and what better place to achieve this goal than the hotel that bears his name.

The next time you are in Deadwood, I encourage you to visit the Bullock Hotel. Talk to some of the employees about their experiences, or better yet, take the guided haunted tour. You will not be disappointed. Even better still, spend the night in one of the twenty-eight rooms. You just might run into Seth as he is making his rounds.

MOUNT MORIAH CEMETERY

Mount Moriah Cemetery has been overlooking Deadwood for almost as long as Deadwood has been in existence. The cemetery was established due to a lack of room for more bodies at the Ingleside Cemetery. This itself is a telling fact, showing how quickly deaths occurred in early Deadwood. Ingleside continued to be used until mid-1878, and then all burials were at Mount Moriah, except for those at the Catholic Cemetery.

In 1877, the Lawrence County government decided to establish a cemetery that would replace the current one. In 1878, the site was selected and named Mount Moriah. Also in 1878, the first burial took place there, and Deadwood also saw the first public burial of a Chinese immigrant. The body of Wild Bill Hickok was removed from its original grave site and moved to Mount Moriah in 1879. On September 25, a devastating fire destroyed much of Deadwood. Mount Moriah's location helped to prevent the body from harm.

One of the most beloved grave sites at Mount Moriah was that of Reverend Henry Weston Smith. The following excerpt is from T.D. Griffith's book *Deadwood: The Best Writings on the Most Notorious Town in the West*. It gives a great background on Preacher Smith and his impact on Deadwood:

> In the midst of the mud and the blood and the rot-gut whiskey that defined Deadwood in the spring of 1876, came an unusual man who sought to spread the word of God among those who desperately needed it. Though his time upon the stage of action was but brief, Henry Weston Smith—the "Pioneer Preacher"—left an indelible mark on the young man.

Preacher Smith came to Custer, a small town in the southern part of the Black Hills, early in 1876. He had worked at mining and other jobs before his arrival. According to Captain C.V. Gardner, Preacher Smith linked up with one of Gardner's freight trains at Custer in May 1876 and arrived in Deadwood. He quickly found work helping to construct the Boulder Ditch. The ditch was pushed to be completed but actually never was and is considered a huge failure. Many people worked on the ditch, and a good number of them received no compensation. We are not sure if Preacher Smith was one who worked and was left without payment.

John S. McClintock, an original Deadwood pioneer, gave this account of Preacher Smith:

> *My first contact with the Reverend Smith was on a Sunday shortly before his death. As I walked down Main Street I noticed a large gathering of men on the square at the end of Gold Street and heard someone speaking in a loud voice. Thinking only of auctioneers and street fakirs, I walked close to the speaker before I realized that I was in the presence of a minister of the Gospel, who was speaking in an easy, unaffected manner as though he might be at home addressing members of his congregation. A score or two had hats off, listening intently to his discourse, while the great mass moved about restlessly, apparently paying but little attention to the speaker's remarks. However, no words were spoken to interrupt or embarrass him. Although I did not get his text, if he had given out any, I listened for a while to his sermon and was very favorably impressed by his manner and speech and unmistakable sincerity. I thought but little about the occurrence until after his murder when I learned something of this man who had been toiling six days a week and traveling twenty miles on foot and preaching two sermons on the Sabbath. It was then I realized, as I believe many others did, that the people of Deadwood had lost a man who spoke to the multitude of people in the valley here, as a true disciple and an earnest follower in the footsteps of the Master who preached on the Mount nearly two thousand years before.*

Preacher Smith was murdered on Sunday, August 20, 1876. He had completed a sermon in Deadwood on Main Street and was on his way, by foot, to the town of Crook City to deliver a sermon there later that day. This was routine for Preacher Smith, and he traveled alone. His body was found about five miles outside Deadwood, lying on the trail. He had been shot. The body was originally buried elsewhere, but it was exhumed and interred at Mount Moriah in 1883. A statue of Preacher Smith was erected in 1891

A True Wild West Ghost Town

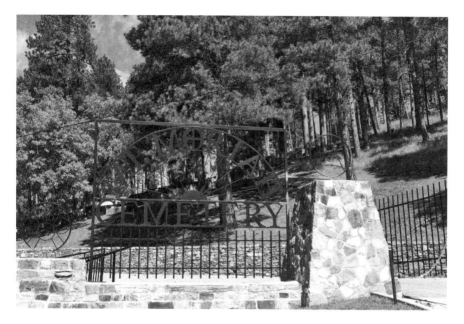

Entry gate to Mount Moriah Cemetery. *Photo by Mark Shadley.*

but was made from sandstone, which eroded due to weather and various "relic hunters," and it collapsed in 1933.

Records for anything besides burials can be sparse, but the April 23, 1880 edition of the *Black Hills Daily Times* indicates that a reporter visited Mount Moriah and noted that many of the wooden stakes or boards that marked many of the graves had been destroyed by weather and time. The same reporter also found that an Italian marble footstone was gone, stolen by a vandal. Yet another article from July 21, 1886, of the same *Black Hills Daily Times*, reported a public opinion:

> [Mount Moriah is in] *a state of neglect and ruin. In laying out lots no thought was given to such matters as streets. So crowded are the grounds that it is impossible to drive through them without being compelled to go over numberless graves. The one road of which the place boasts is so badly washed out as to make it extremely dangerous for one to venture there with a team.*

In the spring of 1893, a stone wall with a cast-iron fence on top was built around the grave site of Wild Bill Hickok to prevent further damage from vandals. Further measures meant to keep Mount Moriah from becoming

unsightly included a change to the standards that were set in place regarding grave markers. It stipulated that all grave markers needed to have a foundation of stone, stone masonry or concrete that reached below the frost line. This was to prevent tombstones that were set improperly from leaning.

In the summer of 1901, souvenir hunters did serious damage to the graveside statue of Wild Bill Hickok. The August 23, 1901 issue of the *Daily Pioneer-Times* reported the event:

> *Vandals have finally ruined the famous statue of Wild Bill that has for years marked his resting place in Mount Moriah cemetery. Within the last few days some one has broken the head from the trunk, and it lies on the ground at the foot of the monument, hopelessly detached...most of the mustache, portions of the long hair, bits of the shoulders and even some of the nose had been removed, defacing the figure until it was scarcely recognizable and bore little resemblance to what it was originally.*

The cemetery has numerous divisions. The northwestern portion used to be the final resting place to many Chinese citizens, but they were exhumed and returned to China for reburial due to religious reasons. This is why

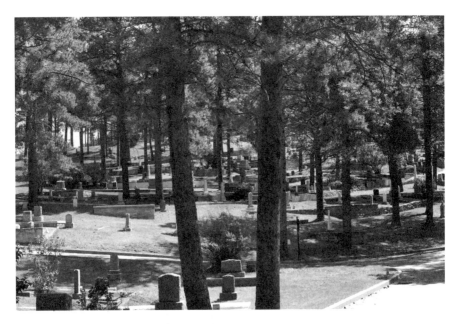

Today, Mount Moriah Cemetery is nestled peacefully among pine trees on a hillside overlooking Deadwood. *Photo by Mark Shadley.*

A True Wild West Ghost Town

this section contains so few graves currently. Deadwood's Jewish community purchased another section in 1893. This is the northern portion of the cemetery, and many of the headstones are inscribed in Hebrew. The Masons have their own section, in the center of Mount Moriah. Many of Deadwood's wealthiest and most prominent residents were Masons. Due to this, the center section is one of the most attractive and has elaborate stones.

Three areas are referred to as potter's fields. These areas are the final resting places for many of early Deadwood's inhabitants of an unsavory nature, including many "soiled doves." These graves are largely unmarked. One of Deadwood's inhabitants who could be described as unsavory is not buried in this location. In fact, she has her own elaborate site and is pointed out on the walking tour of Mount Moriah. Dora DuFran was a longtime madam in the area, including Deadwood and surrounding cities Rapid City, Lead and Belle Fourche. DuFran, despite being involved in prostitution, apparently was a good soul. All who knew her had nothing but fine words to speak of her. She was also a close friend of Calamity Jane's and even employed her from time to time. She also is responsible for the structure seen at Jane's grave site. It's identical to DuFran's and impossible to miss.

There is a mass grave at Mount Moriah as well. On March 10, 1883, a fire broke out near Brownsville, outside Deadwood. People were sleeping on the second story of a boardinghouse near the lumber mill where they worked. The fire is believed to have started in the kitchen, and smoke quickly billowed into the sleeping quarters. Some of the men escaped only to go back in for some reason, perhaps to help those who were trapped. Sadly, eleven men were killed, while four other men escaped with severe burns. The mass grave and monument were established shortly after in memoriam.

The cemetery has become a fixture of Deadwood's tourist scene and is visited by thousands of people each year. The records of the burials are public and contain some causes of death that would be expected, but many others are very unusual. Included in the listing for cause of death are childbirth, bad whiskey (also known as alcoholism), opium, catarrh, dropsy of the heart, summer complaint, softening of the brain, inflammation of the bowels, want of vitality, God knows, killed by Indians, teething, old age, hobnail liver (cirrhosis), broken thumb, struck with bar glass, hanged by vigilantes and from eating fourteen hardboiled eggs.

John Perrett ("Potato Creek Johnny") was one of Deadwood's most popular residents. Perrett left for the Black Hills at age seventeen with his father and sister in 1883. After arriving, Johnny held many different menial jobs. By the age of twenty-five, Johnny was four feet, three inches tall and

decided that he would be a gold miner. Only large mines in the Black Hills were producing the larger quantities of gold. He claimed a spot on Potato Creek, which is where his nickname came from. Johnny let his appearance go, growing out his hair and beard and assuming the stereotypical prospector look. In 1907, Johnny married Molly Hamilton from Belle Fourche. They never had children, and the marriage was reportedly tumultuous. By late 1928, the two had divorced.

The following year, Johnny's fortunes would quickly change. He found one of the largest gold nuggets in the Black Hills. Several sources claimed that the nugget was actually a melted mass of gold ore that had been stolen from one of his neighboring miners. That fact was never substantiated. The nugget weighed seven and three-fourths troy ounces and was purchased for $250 and put on display at the Adams Museum. Johnny quickly became a celebrity in the area and a tourist attraction in his own right. Everyone wanted to hear Johnny's stories, and he was glad to share. Deadwood used Johnny as a promoter for tourism. His cabin on Potato Creek was open for visitors to see in the late 1930s and into the 1940s; he would pan for gold there and share stories with tourists. Johnny died at the age of seventy-seven in 1943 and was buried in Mount Moriah. He was buried next to two of Deadwood's most notable residents, Wild Bill Hickok and Calamity Jane.

Several employees as well as visitors have had different experiences of a paranormal nature at the cemetery. Some visitors have reported seeing spirits of Chinese workers wandering throughout the cemetery at night. Employees also have reported strange occurrences on the cemetery grounds. Two young women reported that while closing the cemetery, it's necessary to walk through the grounds to ensure that guests have left. When walking the grounds, the two would often catch glimpses of shadows moving around the cemetery. Upon investigation, the employees were unable to track down the cause of the shadows.

Another employee was certain that the cemetery was haunted. She said that when closing the cemetery one evening, she shut the large metal gates. She turned around only to find that the gates had returned to being fully open. Something or someone had just reopened the gates, and it couldn't have been gravity. This happened on more than one occasion with this particular employee.

Several employees reported that while closing the gift shop, unusual noises could be heard coming from the cemetery itself. When they tried to listen more closely, the noises were actually voices. It seemed to be an entire conversation, with multiple voices involved. The employees became

A True Wild West Ghost Town

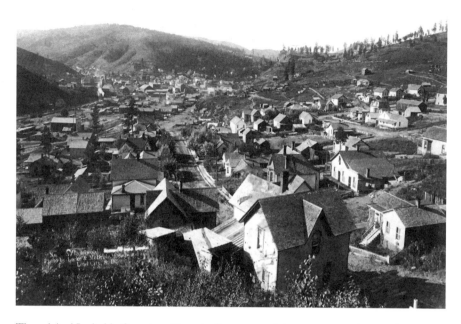

The original Ingleside Cemetery. Note the fence around the cemetery and grave sites, as well as the homes beginning to encroach on the property. Mount Moriah Cemetery is just up the hill. This photo shows how Mount Moriah and its residents are in eternal rest overlooking the town they helped build. *Courtesy Deadwood History, Adams Museum Collection, Deadwood, South Dakota.*

worried that there may still have been visitors in the cemetery despite it being closed, so they went to investigate but found no one present. The voices ceased for the time being. Many employees also said that some people would not work alone in the cemetery or gift shop due to the unusual events that they had experienced.

THE ADAMS HOUSE

The neighborhood where the Adams House now stands is often referred to as the Ingleside neighborhood of Deadwood. It is also referred to as the presidential neighborhood for the streets that are named after U.S. presidents. The first Deadwood cemetery was originally located in the Ingleside district in 1876 and would become Wild Bill Hickok's first burial site. As Deadwood's population grew and homes began encroaching on the cemetery boundaries, a decision was made in 1878 to move the cemetery up the hill a short distance to Mount Moriah. Unfortunately, those responsible for keeping accurate burial records apparently did not, and not all of those buried in the cemetery were accounted for. Over the years, residents of Ingleside have uncovered human remains in their yards, and as recently as March 2012, skeletal remains were uncovered in a private backyard while workers were digging a trench for a retaining wall.

HARRIS FRANKLIN

Harris Franklin, not W.E. Adams, built the house that has become known today as the Adams House, located in the upscale Deadwood neighborhood of Ingleside. Harris Franklin, a hugely successful entrepreneur during Deadwood's early years, built the house in 1892. The home was built in the popular Queen Anne style that was a common architectural design among the rich of this era. An article written on November 22, 1892, in the *Deadwood Daily Pioneer* described the house while still under construction:

A True Wild West Ghost Town

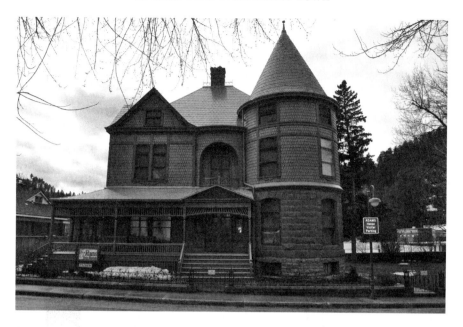

The Adams House, built in 1892. The house looks much the same today as on the date it was finished. *Photo by Mark Shadley.*

The handsome residence being built by Tuplin & Johnston for Harris Franklin, on Ingleside, is nearly ready for the plasterers. It is two stories, of the Queen Anne style, 47x59 feet, and will contain ten large rooms. The first story is built of stone and the balance covered with metallic shingles. The interior is to be handsomely finished, the first floor in natural oak and the balance in pine, in addition to which there will be considerable expensive tiling. The wires are laid for both electric lights and bells. The residence completed will cost upwards of $20,000.

Once built, the Franklins were known for their grand parties, and the home was the talk of the town. Many believed that it was indeed the finest home in the West. The August 22, 1896 edition of the *Black Hills Daily Times* concurred:

The magnificent residence of Mr. and Mrs. Harris Franklin, on Van Buren street, Ingleside, this city, has lately been renovated and beautified by a corps of artists sent out here for that purpose by Mitchel & Holback, of Chicago. To say it is one of the handsomest houses in the state scarcely expresses it. Indeed, we venture the assertion there is not a more beautiful home, in all respects, northwest of Omaha.

During the Franklins' twenty-fifth wedding anniversary celebration, the smoking room located in the attic caught fire when a maid was lighting an oil burner. Harris and his son, Nathan, were able to put the fire out using a Turkish rug. Their quick action averted a devastating fire that could very well have destroyed their beautiful home. After living and entertaining in the home for a decade, Harris's wife, Anna, died in 1902 after a long illness; her body laid in state in the parlor of the house before her burial at Mount Moriah Cemetery. In 1905, Harris remarried and sold the house to Nathan and his wife, Ada, for one dollar. Harris and his new wife left Deadwood to eventually live in New York.

Nathan Franklin

Nathan followed in his father's footsteps, becoming a successful businessman in his own right; he went on to be mayor of Deadwood. He and wife Ada continued the tradition of hosting opulent parties at the house just as his parents had done, and took their place among the social elite of Deadwood. During the 1916 mayoral race, Nathan ran against W.E. Adams, a former four-term mayor of Deadwood. Nathan won the grueling campaign; however, their political differences did not deter Nathan from later selling his home to Adams. In 1920, Nathan and Ada left Deadwood and moved to New York. The Franklins may have moved away from Deadwood, but the Franklin name and influence is still in evidence today in the form of the Franklin Hotel on upper Main Street.

William Emery (W.E.) Adams

W.E. Adams came to Deadwood in the spring of 1877 with his brother, James. W.E. started out trying his hand at gold mining, while his brother established the Banner Grocery store on Main Street. W.E. soon found that mining was tough work and decided to partner with his brother; they went on to become successful businessmen. The fire of 1879 burned their grocery store to the ground; not to be deterred, they went on to

A True Wild West Ghost Town

build a new store at 629 Main Street. During this time, W.E. was building a home in the Forest Hill neighborhood after marrying Alice Burnham. He and his wife went on to have two daughters, Lucile and Helen. Ten years after the fire in 1889, James decided to move to California and sold his interest in the business to his brother. Several years later, W.E. moved his business to Sherman Street and built what is known today as the Adams block, across from the site of the current Adams Museum. He went on to serve four consecutive terms as mayor and is credited with paving many of the roads in Deadwood. In 1920, Adams purchased the home Harris Franklin built, at 22 Van Buren, from Nathan Franklin for $8,500.

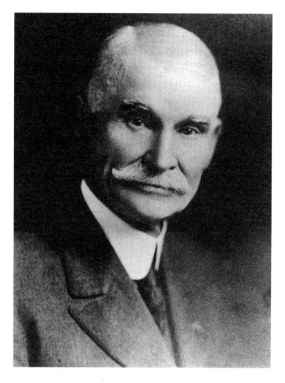

William Emery (W.E.) Adams, a prominent businessman and entrepreneur and guiding force behind the construction of the Adams Museum. *Courtesy Deadwood History, Adams Museum Collection, Deadwood, South Dakota.*

In 1925, tragedy struck when Adams's wife, Alice, died in California while visiting their pregnant daughter, Helen. Suffering from grief and stress from the death of her mother, Helen went into early labor and delivered a baby girl. Due to complications with the premature delivery, Helen died the following day; her infant child died a few hours later. Adams lost his wife, daughter and granddaughter in just a few short hours. (Adams's other daughter, Lucile, had died years earlier from typhoid.) Adams was grief-stricken; he was now alone for the first time in forty-five years. Just as Deadwood rose from the disasters that befell it over the years, Adams's indomitable spirit would rise up once again to find love, and he went on to build a lasting memorial to those he lost.

Haunted Deadwood

In 1927, while on a train to Deadwood, Adams met the Lead beauty Mary Mastrovich Vicich and became smitten. He began a campaign of wooing Vicich, without too much luck at first; however, either through true love or the fact that Adams was wealthy, Vicich soon relented. They were wed that same year in California. Adams had the town gossipmongers' tongues working overtime as Mary was only twenty-nine and he was seventy-three. Although their life together would be short, Adams and Mary had a happy and loving marriage. When talk began about building a museum in Deadwood, Mary encouraged Adams to financially support the project as a lasting memorial to his first wife, daughters and grandchild. Adams practically funded the whole project, and the Adams Memorial Hall Museum was dedicated on October 4, 1930.

During a business meeting on June 7, 1937, Adams suffered a debilitating stroke. He was taken to his home on Van Buren, where he died on June 16, 1937. Mary was at his side when he passed. Adams's body lay in state in the museum he had dedicated to his family and the early pioneers of Deadwood he loved so much. His body was transported to the Adams mausoleum in Pasadena, California, where he now lies in eternal rest.

After Adams's death, Mary closed up the house and moved to California. When Mary visited Deadwood, she never stayed in the house that Adams left her in his will; instead, she stayed at the Franklin Hotel or with friends. Interestingly, Mary confided to some of her acquaintances around Deadwood that the home was haunted and that she did not like being in the house alone. Many speculate that this is the reason she never stayed in the home alone on her visits to Deadwood. Others believe that it was just a clever ruse devised by Mary to keep the home safe from vandals and trespassers. Whatever the reason, the home remained vacant for more than fifty years until Mary sold it in 1987. Mary Kopco, director of the Adams Museum and House, related that many residents of Deadwood avoided walking in front of the old house, believing that it was truly haunted. As for keeping out vandals and trespassers, Kopco confirms that there was little damage to the home from vandals or trespassers and believes that there is little doubt that the haunting story played a significant role in this fact.

The new owners operated the house as a bed-and-breakfast until 1992, when they sold the home to the City of Deadwood, which continued operating the home as a B&B until 1995, when the furnace broke down. In 2000, after an extensive restoration of the house, the historic Adams House Museum was opened to the public.

A True Wild West Ghost Town

Ghost Stories

When we began our investigation into the Adams House, several people came forward to tell us about their personal ghost stories while being in the house. We soon realized that the stories we heard were similar in nature and paralleled the historical record. It seems that it is quite possible that the story Mary Adams told about the house being haunted might not have been a clever ruse after all.

Mary Kopco, Adams Museum and House Director

When Mary Kopco became director of the Adams Museum and House in 1995, she had no idea that the job would also include stewardship over ghosts. Over the years, Kopco has had some interesting experiences that convince her that the past residents are still around and active. Kopco told us about her first ghostly experience, which she had shortly after coming to work at the Adams Museum and House:

> *I came to work for the Adams house in the spring of 1995 and was living in the home next door to the Adams house. I lived just north of the Adams house and could look out my window and see the turret side of the house. It was probably October–November 1996 in the late afternoon when I looked out my window and saw a shadow of a tall, thin man pacing back and forth past the second-floor window in the turret room, where Mary's room is located. I immediately thought someone had broken into the home, as the house was closed. I should have called the police, but my son tells me, "No, Mom, that's just Mr. Adams; he likes you." Well, I can tell you the hair on the back of my neck stood on end, but I knew I had to check out the house. I entered the house and called out to anyone that may have been in the house but got no response. I checked the whole house and did not find anyone. All the doors and windows were locked.*

Kopco told about another experience she had at the Adams House. This time she had witnesses:

I had family visiting, and we had walked to a nearby restaurant for dinner. On our way home, I noticed there was a light on in Mary's room. [The same room where she witnessed the shadow of a man.] I thought one of the employees had failed to turn off the light, so I opened the house and we all went inside. As I started upstairs to turn off the light, we all clearly heard footsteps coming from upstairs. I thought maybe one of the employees was still in the house. I called out, but no one answered. We checked the house and found no one there, and all the doors and windows were secure. We all got the chills. I turned off the light, and we all left the house.

Kopco went on to tell of strange happenings with a Christmas tree in one of the bedrooms:

Some of the docents had placed a small, decorated Christmas tree in Alice's bedroom one year. Every night, they would lock up the house, and the next morning when they would return, they would find that all of the decorations that were on the tree were removed and laying on the floor, and the tree was still standing. What is strange is the fact not one of the decorations were broken. That tells me the decorations did not just fall off the tree, because the decorations are the fragile glass type. And, this happened more than once.

Kopco told us that the Adams House, at one point, was a city-owned and city-operated bed-and-breakfast before it was renovated and turned into a museum. Kopco related a story that a city employee had while working at the house during this time:

I remember a story Bernie Williams told me about working at the Adams House when she came face to face with Mr. Adams. She [Williams] was a city employee working at the house when it was a bed-and-breakfast. She was out back smoking when she turned and saw a tall, thin man looking at her. I remember her telling me the man just stared at her. She looked away, and when she looked back, the man was gone. Bernie later saw a picture of Mr. Adams and said that was the man she saw staring at her.

A True Wild West Ghost Town

Hayley Chambers, Adams House Curator

Hayley Chambers came to work for the Adams House in September 2010 and spends the majority of her time restoring and cleaning household artifacts. Hayley related that she has had a few strange encounters while in the house but has never felt threatened:

> *I spend a lot of time in the house, and there have been a couple times when I will hear what sounds like aimless chatter in other parts of the home. Or if I am downstairs, it will sound like people are talking upstairs. Sometimes, I think it might be a tour group coming through the house, so I will go check. When I do, I find no one else is in the house at all. I have had this happen to me more than once. Other times, when I am working on something, I get an overwhelming feeling that someone is watching me. I'll look around, but no one is there.*

Chambers described another example of strange activity at the house while she was alone in the house:

> *When I lock up for the night, I would walk through the house to make sure all lights are turned off. Usually 5:30 to 6:00 o'clock, after everyone had gone home, a light would turn on. The director who lived catty-corner from the house would come over and turn off the lights, and I would get an e-mail the next day saying we needed to be more diligent in turning the lights off. I would tell her we did turn off the lights.*
>
> *Another interesting experience I had with the lights was one night I had closed up the house and all the lights were off. I was outside waiting for my boyfriend, and I was taking pictures of the house. Nothing strange came out in any of the pictures, but I knew the lights were all off. The next day, the director sent me an e-mail that mentioned the lights were on in the attic at about 6:00, and she had to come over and turn off the lights. This was strange because I went back through my pictures I took that night, and the lights were off.*
>
> *On other occasions, we will set up tables in the parlor and have tea and entertainment, and it feels as if the house will come alive. When there is not a lot of activity in the house, it almost feels heavy. It is very hard to describe the feeling.*

A former employee of the Adams House related a few interesting experiences he had while giving tours of the house:

> *I hadn't been working in the house very long. It was one of my first tours, and I had a couple from Wisconsin I was giving a tour to. We were upstairs, and they walked into Mary's room before I did and asked me how I managed this? I stepped into the room to find the rocking chair was rocking back and forth. The Wisconsin couple realized by the expression on my face that I had nothing to do with the chair rocking. We stood there, watching the chair rock back and forth, when all of a sudden it was if someone had reached out and stopped it from rocking; it stopped immediately. At first, I thought some of the other docents were goofing on me, and I came to find out we were the only ones in the house. It was kind of scary.*

This former employee also described a rather strange experience he had on the back stairs of the house while leading a tour group:

> *One other time, I was giving a tour to a group of people; I was standing a couple steps from the top of the steps that lead up from the kitchen. The tour group was standing in the hallway at the top of the steps facing me. As I was talking, I heard footsteps coming up from behind me. I turned thinking it was one of the other docents coming up behind me, although there was no one there. A lady in the group said, "You're right, I heard those, too." I fully expected to see someone there.*

Investigation

As members of Black Hills Paranormal Investigations, the authors have a front-row seat, if you will, to investigate and experience paranormal activity up close and personal. Quite often, we are able to find reasonable explanations for claims of paranormal activity in the form of house noises, water pipes, loose floorboards, stored chemicals and high electromagnetic fields. However, there are those times during an investigation that we come face to face with unexplained paranormal activity that eludes all of our attempts at understanding.

A True Wild West Ghost Town

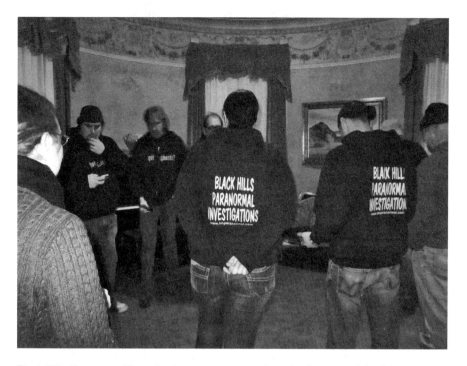

Black Hills Paranormal Investigations team on a pre-investigation tour of the Adams House. *Photo by Mark Shadley.*

After conducting a thorough investigation of the history of the Adams House, including in-depth interviews with witnesses and firsthand accounts of paranormal activity, it became clearly evident to us that there has been a long and consistent history of reported paranormal activity taking place at the Adams House, dating back at least fifty years.

We proceeded to the next phase of our research by conducting on-site paranormal investigations of the Adams House, with the intent of determining reasonable explanations for what has been reported as paranormal activity. Static infrared cameras, motion detectors, electromagnetic field detectors and digital voice recorders were stationed throughout the house in an effort to capture any unusual activity. The paranormal investigators began the task of attempting to debunk the paranormal claims by re-creating the activity through experimentation. During this phase, EMF readings were taken throughout the house, and it was determined there were no extreme readings that could significantly affect those experiencing and reporting paranormal activity. When we began our vigils in the house, conducting EVP sessions, our team began reporting strange experiences.

Several times throughout the investigation, we could very clearly hear what sounded like several people carrying on a conversation in other rooms of the house. The voices we heard reminded us of people having a party. No matter how much we tried, we could not locate or explain the source of the voices we heard. We contacted our command center, located in another building away from the house, to ascertain if any member of the team was outside speaking or if there were pedestrians in the neighborhood. A complete search of the exterior of the house revealed that no one was outside speaking. The voices we heard clearly came from inside the house. Were these the residual echoes of the grand parties known to have been thrown in the home?

Several times during the investigation, we experienced the sounds of doors being mysteriously slammed shut. When we investigated, we found no one else in the house nor could we find the door responsible. We also captured this same phenomenon on our static digital recorders when no one was in the home.

I (Mark) had a rather exhilarating and unexpected experience while filming on the kitchen stairs. While walking up the stairs, I distinctly heard footsteps walking up the stairs behind me. Not only could I hear the footsteps, I could feel a presence, too. Expecting to see another member of the team coming up the stairs behind me, I turned to find no one there. I stood there in silence, trying to make sense of what I had just experienced. I alerted my teammates to my experience and began searching for a reasonable explanation. I played back the video taken during the experience, and the camera's audio clearly captured three distinct footsteps. As I was trying to make sense of this experience, I recalled the experience the former Adams House employee had on these very same stairs. I can honestly say that a shiver went down my spine. We now had documented proof that something still walks the back stairs.

While investigating in the library, we heard distinct whistling. When one of our investigators began whistling in response, we were once again rewarded with more whistling. When reviewing our audio of this session, we were astonished to find that we had captured the ghostly whistles.

During another session investigating the library, this author saw a shadow figure that quickly moved toward the kitchen. I found myself standing in the middle of the kitchen trying to find a source of the shadow I had just seen when I felt something grab my left shirtsleeve and give a tug. No one was near me, nor had I snagged my shirtsleeve on anything; I could not explain the experience. What is interesting is that later in the night, while

in the library, my co-author (Josh) experienced his left elbow being grabbed by unseen hands.

After finishing the initial investigation of the Adams House, a review of the evidence uncovered several compelling EVPs. One recording captured the voice of an older gentleman exclaiming, "Hey," as investigators were walking into Mary's bedroom upstairs. Another recording captured a female humming an unknown tune in Alice's bedroom. While investigators were in the attic smoking room, an eerie EVP of a child's voice can clearly be made out talking over the investigators. One of the most compelling EVPs captured near the smoking room may reference the fire that broke out in the smoking room during the Franklins' silver anniversary. The recording captures an unknown female screaming, "Fire!"

The Adams House, now 116 years old, has been witness to the events of the lifetimes of two of the wealthiest families of Deadwood. It witnessed their grand celebrations as well as their tragedies and deaths. These intense emotional events no doubt left a lasting effect on the home's environment, resulting in the reports of haunting activity. Many of the experiences we encountered and were able to capture also seem to correspond to significant events witnessed in the home over the years. We might not be able to say definitively that a Franklin or Adams family member is haunting the house, but we can safely go on the record and state that something or someone still walks the hallways of the Adams House.

The Adams Museum

To my friends—to my neighbors—and in memory of the dear ones who have graced my fireside I offer this as a token of my love for the Black Hills.
—*W.E. Adams*

In 1927, the Deadwood businessmen's club began discussions to establish a museum in the community to preserve artifacts and documents important to the settlement of the Black Hills and Deadwood. W.E. Adams's wife Mary encouraged him to build the museum to preserve Black Hills history and to serve as a memorial to his first wife and children. A design contest was held, and several prominent architects of the day submitted designs; however, the museum committee settled on a design submitted by a local man, R.L. Ewing.

Once the design was decided and as funding was being worked out, the stock market collapsed, putting the museum project in jeopardy. Not to be deterred, Adams donated his own money toward the construction to get started. Overall, Adams donated a total of $75,000 toward the completion of the museum.

On October 4, 1930, the Adams Memorial Hall Museum was dedicated to a large crowd of dignitaries and Deadwood citizens. When W.E. Adams died in 1934, his body lay in state in the very same museum he dedicated to his family and early pioneers of Deadwood and the Black Hills.

One interesting note about the current site of the Adams Museum is that on September 26, 1879, fifty-one years before the dedication of

A True Wild West Ghost Town

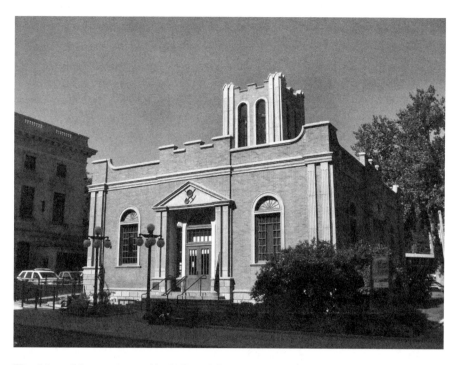

The Adams Museum, opened in 1931 and financed largely by W.E. Adams. When Adams died, his body lay in state in the museum. *Photo by Mark Shadley.*

the museum, Mrs. Ellsner was busy baking bread in the Empire Bakery when she accidently knocked over a coal oil lamp. The fire spread quickly through the bakery and to nearby wooden and canvas structures. The fire, fueled by the wooden structures and a southerly breeze, soon engulfed the hardware store of Jensen, Bliss & Company. Stored neatly away in the storeroom were eight barrels of black powder. When the fire ignited the black powder, a deafening explosion rocked the gulch, sending barrels of black powder shooting into the morning sky like fiery missiles, spreading the already out-of-control fire to other parts of the town.

When all conventional efforts to stop the inferno's rampage failed, buildings in the path of the fire were either torn down or blown up with dynamite to starve it of fuel. Meanwhile, more than two thousand people fled for their lives up the steep slopes of Deadwood Gulch with everything they could carry. They watched in horror as their possessions burned. By the time the conflagration was finally extinguished, more than three hundred buildings, including the business district, courthouse and city hall, had been destroyed, along with important documents. The cost of the fire damage

was estimated at upward of $2 million. That is a huge sum of money for any time period, but in 1879, that was an amount that could easily break a town's will to survive, but not Deadwood. Within hours of the fire being extinguished, Deadwood began rising from the ashes of destruction like the mythical phoenix, and the job of rebuilding began at a frenzied rate.

Today, this site houses the Adams Museum and its many artifacts of the early pioneers who settled the northern Black Hills and Deadwood, reflecting the true pioneering spirit of those who tamed this harsh land. There are those who maintain that some artifacts on display inside the walls of the museum are haunted by those same early pioneers. One case in point is a painting of W.E. Adams that hangs prominently in the museum. Some believe that the spirit of Adams is attached to his portrait and that his spirit becomes active and haunts the museum that bears his name anytime it is moved. Many employees have reported feelings of being watched while working in the museum, while some feel a distinct presence looking over their shoulder. Mary Kopco, director of the Adams Museum and House, has had her share of unusual encounters in the

Portrait of W.E. Adams inside the Adams Museum. It is reported that if the portrait is moved, unusual events occur, possibly of a paranormal nature. *Photo by Mark Shadley.*

museum and described some very unusual activity each time they have moved W.E. Adams's portrait:

> We were undergoing restoration at the museum in 2005 and had to move several exhibits, including a painting of Mr. Adams, to the post office building next door for storage. For as long as I have been here, I never knew the alarm to go off at the post office. The minute we store Mr. Adams's portrait in the post office, the alarms go off. The police respond to find everything in order. In fact, I remember an incident we had at the museum when we moved Mr. Adams's portrait. We needed some room in the museum for an exhibit we were showing and had to move Mr. Adams's portrait to another location within the museum to make room. After this, we continually were having alarm activations at the museum. I would have to come down, and each time we found nothing. From that point on, we would not move Mr. Adams's portrait. I think he likes where he is looking out over the museum he loved.

Any activation of an alarm system in and of itself is not sufficient evidence of paranormal activity since there are many factors that may cause an alarm to activate. However, what is interesting to note in this particular case is that neither of the alarm systems for the museum or post office has activated in this manner since Mr. Adams's portrait was returned to its original location within the museum.

INVESTIGATION

There is a popular theory among some in the paranormal research field who believe that certain artifacts can absorb the energy of those who have used or touched the item, thus imbuing the item with energy that can be captured as haunting activity. In simple terms, some artifacts can be haunted. If this is the case, there are numerous artifacts housed within the Adams Museum that were once owned and used by the early pioneers of Deadwood. One thing is certain: early Deadwood pioneers encountered hardships and tragedies that could very well have left lasting residual energies on the environment and their possessions. Could it be that some of the claims of paranormal activity reported in the museum are simply the residual release of this energy? If so,

Director Kopco believes that the epicenter of that energy may take place in the Pioneer Room, located in the basement of the museum. The Pioneer Room once housed the artifacts and clothing of the early pioneers of the nineteenth century and was open from 1930 to 2005, when it was converted to a conference room. Even though the artifacts have been moved, Kopco claims that the room still has a positive but powerful energy.

During our investigation of the museum, we encountered some interesting experiences in the Pioneer Room. During our initial sweep of the room with EMF meters, we began experiencing a phantom smell of old aftershave. At times, the fragrance was fleeting and faint, and at other times it became very overwhelming. The fragrance disappeared as quickly as we encountered it. We could not find a reasonable explanation or source for this fragrance within or outside the museum. Additionally, our investigators do not wear any fragrance on investigations that can be mistaken for phantom smells for this very reason. Was this Mr. Adams or an early pioneer checking us out?

At one point, we experienced unexplained knocking on the paneled walls of the room. When we investigated the knocking sounds, we found that there were no pipes or open areas in the section of the wall where we heard the knocking. We could not re-create the knocks nor could we explain the sound. Could this knocking have been the result of restless spirits of early pioneers trying to get our attention? If so, they succeeded!

After hearing the knocking on the walls, we were entertained by small balls of light flitting throughout the room. The phenomena only appeared for a fraction of a second at a time, disappearing as quickly as they appeared. Not one piece of our video equipment captured these balls of lights, and we could find no reasonable explanation for the source of these anomalies. These lights are not to be confused with the dust, insect, moisture or pollen orbs that are captured through digital photography. What we experienced were not orbs but rather what appeared to be physical objects emitting their own light. Could these phenomena have been a rare but natural occurrence known as ball lighting? If it was, it certainly was not a rare occurrence in the Pioneer Room of the Adams Museum that night.

Throughout the investigation, sounds of someone walking on the second floor of the museum were experienced by a few of the investigators. Mark Rowland, lead investigator for Black Hills Paranormal Investigations, had an interesting experience while investigating on the second floor:

> *I had started up the stairs and went around to the north side of the second floor and got about halfway across the floor when I heard footsteps and a*

A True Wild West Ghost Town

> *rustling of a dress behind me. I turned around expecting to see someone behind me, but no one was there. I was carrying a handheld digital recorder, but it never captured the sounds of the footsteps or rustling I heard. The rustling sound reminded me of a woman wearing a long dress. After I experienced this, I realized I was the only one on the second floor, and the hairs on the back of my neck really stood up when I realized I was not alone.*

Rowland also captured an interesting EVP that night while investigating the basement:

> *We had just finished up investigating in the Pioneer Room in the basement, and everyone had walked upstairs to the main floor. I decided to check out the schoolroom display in the basement, since some of the team thought they heard movement here earlier. I was the only one in the basement by this time and started towards the stairs. I was kind of humming to myself and walked upstairs. Later, when I was going over my evidence, I was shocked when I got to the part on the recording where I was looking for the stairs. I hear myself humming then what sounds like a male voice giving directions stating, "This way!" I had no idea I had captured something.*

Another investigator with Black Hills Paranormal, Maurice "Mo" Miller, also experienced some strange activity on the second floor that corroborates Rowland's experience. What is interesting about this experience is the fact both Miller and Rowland were unaware of the other's experiences until after the investigation.

At one point during the night's investigation, movement and voices were heard coming from the basement. Later, when the digital audio equipment was reviewed, the sounds of footsteps and movement that corresponded to our experiences were captured, including the recording of a wooden bench being dragged across the floor. This wooden bench is part of a nineteenth-century schoolroom display located in the basement. What is compelling about this audio evidence is the fact that none of the investigators was in the basement during any of these captures. We have to ask ourselves: who or what moved this bench? Could this movement be the residual sounds of early pioneers going about their daily activities?

The experiences encountered at the Adams Museum were interesting to say the least, and the evidence that was captured could very well be the residual energy of past pioneers of Deadwood. Unfortunately, there is not

enough evidence gleaned from the investigation that can clearly point to a specific person or spirit responsible. It would seem, though, that something paranormal was captured in the museum.

The Adams Museum stands today as a tribute to the indomitable spirit of the early pioneers of the Black Hills and Deadwood, as well as a loving tribute to the family of W.E. Adams. One cannot ignore the fact that when the first settlers came into Deadwood Gulch, this was a harsh, untamed land of untapped opportunity. Those pioneers who carved a living from this land gave those who came after them a solid foundation on which to build and prosper. These pioneers experienced hardships that we can only imagine through the stories of those who lived them. Our ancestors were a tough lot, and we should be thankful for their hardiness and sacrifice. All too often when conducting paranormal investigations, some tend to forget that we are dealing with the energy of the spirits of those who came before us. These people had the same needs, dreams and concerns that we do today. They were fathers, mothers, brothers and sisters. So if you ever visit the Adams Museum and notice something out of the corner of your eye or feel the hair standing up on your arms, don't worry. It is likely just the occupants keeping an eye on their belongings.

Haunted Deadwood Walking Tour

Every year, hundreds of thousands of tourists visit Deadwood for any number of reasons, including walking in the footsteps of Wild Bill and Calamity Jane or visiting their final resting places at Mount Moriah Cemetery. Then there are those interested in Old West history who find Deadwood an irresistible treasure-trove of nineteenth-century history. Others visit Deadwood solely for the thrill of experiencing something that goes bump in the night. No matter what the reason, Deadwood easily accommodates them all.

However, the only way to really experience Deadwood's unique personality is to get out of your car and walk the streets. Deadwood is a rather small town, and most of the attractions are within close and easy walking distance. Walking the streets of Deadwood can easily be accomplished in little more than an hour or it can take all day, depending on how adventurous you feel. If you want someone else to do the driving, Deadwood does provide a trolley service for a small fee.

In this chapter, we will outline an easy self-guided walking tour that will be informative and fun, as well as point out the haunted locations talked about in earlier chapters. Most of the route is easy walking and should present no problems for most people. However, when the walking tour takes you toward the Adams House and Mount Moriah, the path does become very steep. Those not accustomed to strenuous physical activity or who have

small children are advised to take a vehicle or the Deadwood trolley. There is free parking at both the Adams House and Mount Moriah. If you decide to walk, make sure you bring plenty of water to hydrate. Many people do not realize that Deadwood is nearly a mile in elevation, so please take this into account when you plan your walking tours. And do not forget to bring your camera!

Self-Guided Walking Tour

Once you have parked, make your way to lower Main Street near the Mineral Palace. This is the north or lower end of Deadwood, where Chinatown was located. Take time to look around. You can still see some of the early Chinatown building foundations in the hillside. Several years ago, a major archaeological dig uncovered numerous Chinese artifacts in this area.

You are also in the general vicinity of the site of the Lone Star Saloon and Kitty LeRoy's murder. The Lone Star, if you remember, was the site of the first ever reported haunting in Deadwood in 1878. The Lone Star building was later swept away in the raging waters of Whitewood Creek in the flood of 1883.

Walking up the street, you are now where the raucous Badlands district of Deadwood was located. You will notice a row of buildings on your right-hand side just after the bend in the road. Take a look up at the second-floor windows. Those are not spirits staring back at you; those are mannequins placed there by business owners as a reminder of this block's sordid past. Behind these second-floor windows were the various brothels that flourished until they were raided by the federal government in 1980. It is also the location of some very exciting haunting activity.

Before we explore these buildings, take time to look across the street to where the Mineral Palace is located. This site was once the original location of the infamous Gem Variety Theater, which the notorious Al Swearingen operated until it burned down for the final time in 1899. In its day, the Gem was known worldwide for its entertainment and wild times. However, there was a dark side to the Gem and to Al Swearingen.

Swearingen traveled to eastern cities advertising for women to work as maids or cooks in his theater; however, women who took him up on his job offer realized soon upon arriving in Deadwood that they were not going to be doing any cooking or cleaning. When they objected, Swearingen reminded

A True Wild West Ghost Town

LOWER MAIN STREET

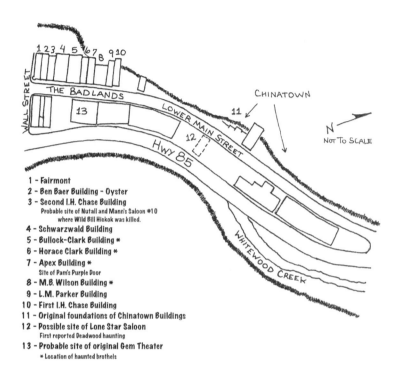

Illustration by Mark Shadley.

them that he had paid for their travel and costs and threatened them with jail for breach of contract. Many of the women had no other means and were forced into prostitution. Others found that the only way to end their misery was to commit suicide. With the amount of death and negative energy associated with this property, one would think that this location would be highly active. However, while conducting interviews, we found no reports of any paranormal activity whatsoever.

As we bring our attention back to the row of buildings on the west side of the street, the Apex Building's second floor once housed Pam's Purple Door brothel, which was shut down in 1980. The building with the ornate bay windows is the Bullock-Clark Building, which was the site of the original Bella Union Theater and the IXL Hotel that burned down in the 1879

fire. This building once housed a Salvation Army barracks for women and children on the second floor before the brothels moved in.

Continue a few steps more and notice the hanging sign advertising this as the original site of Wild Bill Hickok's death on August 2, 1876. The basement of this building is said to be the original site of Nutall & Mann's Saloon #10, where Wild Bill engaged in his final poker game. No one knows the actual location of the #10, but most agree that this site is the most likely location. Ron Russo, the current owner of the Fairmont Hotel, claims that Saloon #10 was located in his back parking lot closer to the hillside. We may never know for sure since all records of early Deadwood building sites were destroyed in the fire of 1879. (This could be the result of a popular myth that Broadway Street, the current alley running behind these buildings, was once the original Main Street; however, early photographs of Main Street tend to dispel this rumor.)

You are now approaching the site of the Oyster Bay Bar and Fairmont Hotel. At this point, you probably are noticing the stairs that lead down in front of the Fairmont. Take the steps down and you will find yourself standing at the original elevation of 1876 Main Street Deadwood. Years later, this walkway was used as a sneaky way for those not wanting to be seen going to the brothels to sneak in the back door. Take some time to walk around inside the Fairmont Hotel. If you are lucky, you may run into the owner, Ron Russo. He has quite a few interesting stories about this great old building.

Once you have had the opportunity to explore these buildings, step across the street to the Bullock Hotel. I know you are excited to walk around inside the hotel, but take a moment to look back down Main Street from the direction you came. You are now standing at Wall and Main Street. Wall Street was the dividing line between upper Deadwood and the infamous Badlands. It is rumored that an imaginary line was drawn across Wall Street by Sheriff Bullock and Al Swearingen, denoting each other's authority in both locations.

Imagine the sounds and smells of an earlier Deadwood: freight wagons fully loaded with much-needed freight pulled by rows of oxen lining Main Street, the snap of the whip through the clear pine-scented mountain air, the sounds of hammers pounding nails as buildings are frantically being built and miners excitedly talking about gold discoveries. Listen a little closer, and you just may hear the gunshot that killed Wild Bill. This section of Main Street has an incredible amount of history, as well as a history of hauntings. Take the time to explore and talk to the employees about their experiences. You just might experience a pioneer of the past brushing up against you.

A True Wild West Ghost Town

UPPER MAIN STREET

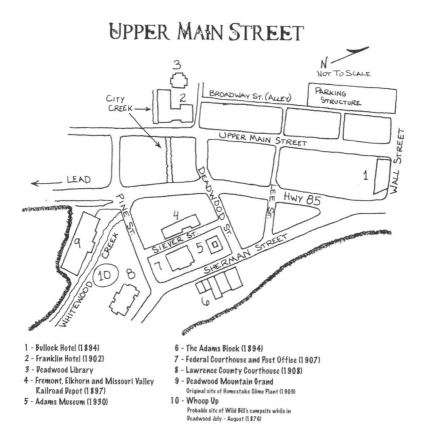

1 - Bullock Hotel (1894)
2 - Franklin Hotel (1902)
3 - Deadwood Library
4 - Fremont, Elkhorn and Missouri Valley Railroad Depot (1897)
5 - Adams Museum (1930)
6 - The Adams Block (1894)
7 - Federal Courthouse and Post Office (1907)
8 - Lawrence County Courthouse (1908)
9 - Deadwood Mountain Grand
 Original site of Homestake Slime Plant (1909)
10 - Whoop Up
 Probable site of Wild Bill's campsite while in Deadwood July - August (1876)

Illustration by Mark Shadley.

I feel it necessary at this point to warn any of you who might be tempted to find a way to explore the second floor of these businesses. They are off limits to the general public, and special permission is required. If you do not have permission, you are trespassing and will be arrested. Please do not go into off-limit areas unless you obtain the proper permissions. Please respect property rights.

As you stand in front of the Bullock Hotel, take a moment to look east on Wall Street, down the narrow street that leads toward the main highway. Today, this highway conceals the once wild path of Whitewood Creek. Notice that the creek flows very close to the rear of the buildings on Main Street. Take a close look at the different style of brick used to construct the hotel. No, they did not run out of brick—they simply incorporated the

Haunted Deadwood

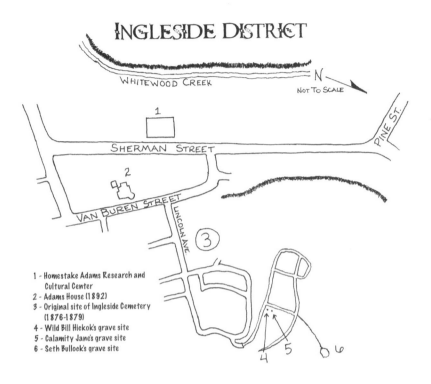

Illustration by Mark Shadley.

existing fireproof warehouse that Bullock and Star built for their hardware store into the hotel construction. The original metal shutters are still affixed to the windows.

Once you have had an opportunity to fully explore the Bullock Hotel, step out onto Main Street and look straight across the street at the hillside above the modern parking structure. The home with the green Mansard-style roof was the home of Judge Granville Bennett, first judge of Deadwood, and his daughter, Estelline Bennett, who wrote *Old Deadwood Days*. She wrote about early Deadwood and her firsthand experiences overlooking the infamous Badlands.

Our next stop in the tour is the Adams Museum, located at Deadwood and Sherman Streets. However, as you stroll up Main Street, take in the street life and some of the interesting businesses lining the street. On your way to the museum, you will pass by the Franklin Hotel, built in 1903. When built, the Franklin Hotel was one of the finest hotels and had many popular

A True Wild West Ghost Town

amenities, including telephone service. If you walk to the south side of the hotel, you will notice what appears to be a storm drain. This is actually City Creek, which flows into Whitewood Creek and was the site of extensive placer mining.

There is no entry fee at the Adams Museum. However, the staff do accept small donations, so take some time to go inside and look around at some of the early Deadwood pioneer artifacts. There is one interesting display detailing the brothels of Deadwood. The museum also has the original door to Pam's Purple Door brothel on display. On the main floor, you will notice W.E. Adams's portrait hanging prominently. If moved, this is the portrait that purportedly creates some unusual activity in the museum. Once you have taken the time to look around, we are going to head to the more strenuous part of the tour.

When you leave the museum, you will want to go south, or to your right, on Sherman Street. You will walk past the post office and county courthouse as the street jockeys to the left. On the right-hand side of the street, where the current city hall is located, there was once an area called Whoop Up. This is where Charlie Utter and Wild Bill Hickok camped when they came to Deadwood. As you continue up the street, you should begin to notice homes on the hillside on your left. This is the Ingleside neighborhood of Deadwood. The original Ingleside Cemetery was located here, and this is where Wild Bill Hickok was originally buried. If you look farther up the hill, you can make out where Mount Moriah is located.

When you reach Cemetery Street, turn left and follow the road around to the right. It will turn into Van Buren Street, and just a few yards ahead of you is the Adams House. Tours are provided to the public for a small fee and usually take about thirty minutes. The staff are friendly and enjoy discussing their paranormal experiences. Tell them we sent you! This won't get you a discount on your entry fee, but it will surely be an interesting topic of discussion.

Head back down the street and turn right onto Lincoln Avenue. At this point, this is the steepest part of the walking tour. If you are looking up Lincoln right now, thinking to yourself, "What was I thinking?" you know exactly what I am talking about. For those of you who like a challenge, get to walking!

Once you have made it to the top of the hill, you should see the front entry gate to Mount Moriah Cemetery. As with the inhabitants of Mount Moriah, you have reached your final destination, too, hopefully in better shape than they did. Once you have paid an entry fee, make sure to get a map of the cemetery. This will guide you to the interesting locations within

Haunted Deadwood

the cemetery and give a little background information on those buried here. Obviously, among the most popular attractions of the cemetery are Wild Bill's and Calamity Jane's graves. Once you have taken the time to walk around, check out the stunning panoramic views of Deadwood and the surrounding hills from some of the lookouts.

Whether you walked or drove our little tour, you were exposed to just a small bit of historic Deadwood and its haunted history. We focused on locations that have had long histories of haunting activity. For those who work and live in Deadwood, this haunting activity has become part of the experience that is Deadwood. We hope you had an opportunity to experience a glimpse of old Seth walking the hallways of his hotel or see the ghostly eyes staring back at you from the second-floor brothels on Main Street. If you did not, don't worry. If you spend any amount of time in Deadwood, chances are you will experience something interesting in this original Wild West ghost town.

BIBLIOGRAPHY

Ames, John. *The Real Deadwood*. New York: Chamberlain Bros. Inc., 2004.

Bennett, Estelline. *Old Deadwood Days*. Lincoln: University of Nebraska Press, 1982.

Griffith, T.D. *Deadwood: The Best Writings on the Most Notorious Town in the West*. Guilford, CT: Morris Book Publishing, 2010.

Kopco, Mary A. *The Adams House Revealed: The Restoration of a Historic Home*. Sioux Falls, SD: Mailway Printers, 2006.

Lee, Bob. *Gold, Gals, Guns, Guts*. Deadwood, SD: Deadwood-Lead '76 Centennial, Inc., 1976.

McClintock, John S. *Pioneer Days in the Black Hills*. Norman: University of Oklahoma Press, 2000.

Mitchell, Steven T. *Nuggets to Neutrinos: The Homestake Story*. Bloomington, IN: Xlibris Corporation, 2009.

Parker, Watson. *Deadwood: The Golden Years*. Lincoln: University of Nebraska Press, 1981.

BIBLIOGRAPHY

Toms, Don. *Tenderloin Tales: Prostitution, Gambling and Opium on the Gold Belt of the Northern Black Hills, 1876–1915.* Pierre, SD: State Publishing Company, 2004.

ABOUT THE AUTHORS

Mark retired in 2008 after serving thirty years as a police officer. He and his wife, Peggy, a retired crime scene investigator, moved to the Black Hills of South Dakota. Mark and his wife became members of Black Hills Paranormal Investigations, for which he is one of the current lead investigators and historical researchers for the team. When not investigating or writing about the paranormal, he enjoys fly-fishing the many trout streams of the Black Hills or pretending to play golf. He enjoys exploring the abandoned ghost towns and mining camps that dot the landscape of the Black Hills. He is also an amateur early American history buff.

Josh Wennes (left) and Mark Shadley.

Josh and his wife, Amanda, live just outside Rapid City, South Dakota. Josh helped to found Black Hills Paranormal Investigations and is currently an investigator as well as public relations representative and

About the Authors

media specialist for the BHPI team. Outside of BHPI, Josh enjoys fishing and being outdoors in general. An avid baseball fan, Josh also plays softball in his spare time. He is an amateur history aficionado, especially regarding the Civil War and World War II, as well as the rich history of the Black Hills.